3-86

drawing figure movement

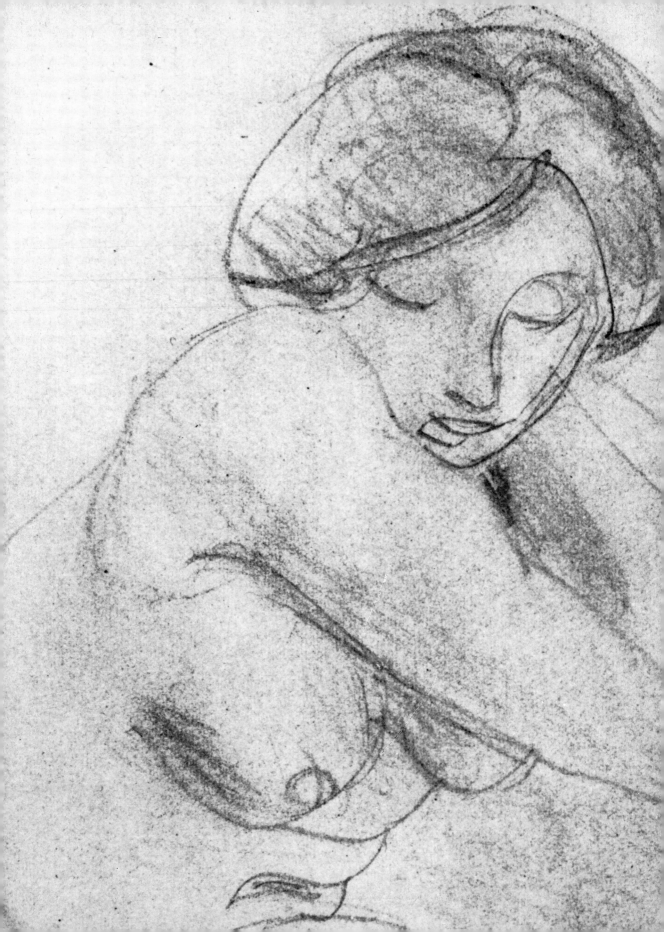

drawing

figure movement

john croney

 VAN NOSTRAND REINHOLD COMPANY

NEW YORK CINCINNATI TORONTO LONDON MELBOURNE

Printed in Great Britain

Published by Van Nostrand Reinhold Company Inc.
135 West 50th Street
New York, New York 10020

16 15 14 13 12 11 10 9 8 7 6 5 4 3 2 1

Library of Congress Cataloging in Publication Data

Croney, John.
 Drawing figure movement.

 Includes index.
 1. Human figure in art. 2. Movement, Aesthetics of.
3. Action in art. I. Title.
NC765.C76 1983 743'.4 82-21854
ISBN 0-442-21596–7

contents

acknowledgment

I should like to thank the several generations of students, who by their interest and continual enthusiasm, have made me consider how best to teach figure drawing, and also talk about drawing and visual communication in a meaningful way.

I am grateful for the ready assistance of the staffs of the Departments of Prints and Drawings of the Victoria and Albert and British Museums; and of the other museums and art-galleries which I have used in the course of my research for the book. I owe a particular thank you to Mr William Bradford, Assistant to the Director of the Courtauld Institute Galleries, for a great amount of his time and for the interest he has shown. He re-checked, and revised where necessary, the description and size of each drawing I wished to use.

Also my thanks to Mr David Grob for allowing me to reproduce the drawing by George Grosz from his collection at the 12 Duke Street Gallery, London.

I must thank Miss Joyce Gadsby for her excellent typing of the manuscript.

I also wish to express my appreciation for the supportive work and guidance of Thelma M. Nye of Batsford during the books creation.

I dedicate the book to my wife to whom I owe a special debt of gratitude for her encouragement and forebearance despite living amongst the apparent chaos of ever multiplying paper.

Croydon 1983 J C

introduction

Let me here take occasion to remark that good drawing is another synonym for movement. A correct drawing may be a valuable artifact, full of desired information about the object reproduced, but it remains a mere diagram unless it has movement as well.

Bernard Berenson

This is a book about how to draw movement in the human figure. Ideally when reading it there should be a piece of drawing paper nearby, on a board or in a sketch book, and a pencil or pen so that drawings or diagrams can be made as suggested in the text, or any other drawing made whilst the feeling for drawing is present.

If the text appears at times to be 'going on a bit', I hope the reader will bear with me. Often when teaching drawing by demonstration, and talking at the same time, one does 'go on a bit'. This repetition seems as necessary as the repetition needed in the mark making process of drawing itself. When teaching there is the chance of modulating the tone of one's voice, or making a repetition of a point in a varying form, and so making this reinforcement more agreeable and acceptable. I have found it difficult to match this process in the written text, and would ask the reader to use the diagrams and reproduced drawings as much as possible to learn what I am 'going on about'.

I have written this book in the belief that those who wish to draw the human figure can do so and that those who can already draw the figure will always wish to improve and widen their scope. Also I believe with Berenson that a drawing is a mere diagram unless it has movement as well; and further that there is no finer subject for the draughtsman than the human figure. In any of its single forms there is movement, and in the articulation of its parts there are countless compositions of movement, each one of which could provide innumerable attitudes for dynamic expression in drawing.

Some sort of training, academic or in a part-time class can be useful and will be valuable for many. Academic training in a number of cases may shackle certain individuals and inhibit their progress. They must study as many good drawings as they can and find their own artistic individuality. There is an artistic anarchist present in so many of us that can only be canalised and developed by the right master. I have tried to say in the text of this book what I know to be the truth about drawing figure movement, but the truth will only finally become apparent when drawings such as those shown in this book have been studied and there has been some continuous practice.

When one gets the hang of it, drawing can be uninhibited and a piece of paper the entry to a magic land where anything can materialise; for drawing allows one to be an artist at all times. Successful drawing is the result of some painful and patient labour. But if time is given to it the process quickens and confidence in mark making is established. Do not turn away for ever if the going gets tough. Turn away maybe, but return, and progress will have been made. Everyone engaged in creative work feels despair at times and it

seems to me now that it is right that there should be troughs of despondency as much as there are the peaks of elation which come with success. The process of drawing sharpens the sight, and brings more and more information and knowledge which in turn sharpens the faculty of self-criticism. The troughs are a sign of what we have learnt and the new things we want to express.

All drawings share a common problem at commencement, and that is what sort of marks should be used and where should they be placed on the paper. In fact where is the beginning? Well, as Alice was told, 'you begin at the beginning and go on until you get to the end'. The first mark is the beginning and it can be from any point of a subject, the second mark made must relate to the first, by distance and by angle to something seen in the subject. The third mark relates in the same way to the previous two and the drawing is built up by related marks that express inside and outside contours and forms and their directions. This process is explained in chapter 3. The beginning therefore is where you choose to make it.

The basic approach to drawing has changed little through the centuries in Europe. Any differences that can be seen in drawings from different centuries are mostly ones of historical detail, social ideas and the relevance or non-relevance of using abstraction in visual communication. Technically there are great similarities in approach between say sixteenth-century and twentieth-century drawings. For example the Joseph Herman *Study from the nude* (1) works by the same technical principles as the Venetian drawing of *Jupiter riding an eagle* by Luca Giordano (2) and they are both fun and fresh for the common reason that both artists enjoyed drawing form movement and the human figure. I think it is important to note the common purpose of the drawings in this book and forget dates and times. Albert Elsen writing on Rodin's drawings said that: 'Through drawing he memorised styles of the past, probed anatomy, and analysed poses and their equilibrium in the work of older artists whether before his eyes or in memory'. This could be written of so many successful artists and draughtsmen. The past will be found as fresh as the present, and it forms a school in which one can feel at ease and learn.

The field of image making has enormously increased however in this century. Techniques may still be free or tight, but attitudes to images have expanded. The invention of photography has had more to do with this than any other single invention, and the expansion has been further widened by the film and television. The fleeting impression captured by the camera was studied by Degas, and he compared quickly drawn sketches with photographic records; and finally he used photographic images and transcribed them into drawings. For the first time artistic expedients in technique could be judged alongside a photographic record of the same subject. The dissection of the moment by the camera led to an outlook in drawing, painting and sculpture that can only be described as revolutionary. The artist was able to form images not only from what he saw in nature, but also from compositions of many views, sections of views, enlargements of parts and the juxtapositions of seemingly unrelated aspects of a subject. The use of cut up photographs pasted together as a montage, and the editing and cutting of cine film material aided this development of new imagery.

Photography and film account then importantly for a more flexible attitude to figurative images by artists but there are other reasons as well. By the beginning of the twentieth century, artists, for one reason or another, had become more neglected by the public, and they no longer had the desire to commit themselves to a patron or the demands of society. Also representation in the literal sense had ceased to thrill artists. An artistic climate developed in which an artist could find his or her own way outside schools and academies.

Drawing always has been a means of examining characteristic style and finding a

personal expression within it. What was new is that twentieth-century drawing broke free of characteristic style, in particular it helped the visual arts break free from representation. Impressions were taken from nature, but as selections or abstractions. The camera ceased to be a rival, and the fidelity of appearance was only used as a fleeting image. Most importantly, it was discovered that abstraction, and technical improvisations prompted by the imagination, could be given pictorial values. One of the most important characteristics of present day drawing that emerged from these discoveries was an awareness of the mystery of the line and what it can suggest. This last fact has added to the present day problems of those wishing to learn to draw. I hope what I have explained in chapter 2 about lines and in chapter 3 about contours will demolish a large number of the problems a learner has with the use of line.

It may be noticed that some draughtsmen have a greater facility of technique than others. Do not be disturbed by this, the ease with which one person draws as against the difficulties experienced by others bears no relationship to eventual success. Many draughtsmen have found that technical difficulties have only served in the end to increase their expressive powers. The struggle manifest in the drawing often provides a large part of its engaging appearance and the tensions it exhibits deepen the enjoyment of the spectator. On the other hand great ease in execution may not provide such a significant image, although this depends so much on the context of the drawing. Facility in technique can be beautiful; struggle expressed in a technique can be equally beautiful. It depends on occasion, context, style, perhaps even on fashion; facility or struggle can both produce outstanding results. Individuals will finally each produce their own style by their own means and experiences; luckily in the field of drawing the range of expression is infinite.

To draw figure movement successfully it is necessary to learn to 'see' how its moving parts are related to one another three-dimensionally, and this means learning to see analytically and so be able to comprehend its structure in drawing terms. It is for this reason that chapter 1 'Discovering movement and the image' and chapter 2 'Drawing marks and how they are used' were written. Chapter 3 then considers the execution of a drawing. The three chapters together deal with the essential problem of figure drawing which is the establishment of main masses and their relationship to one another in space.

Whilst writing about technique and practicalities, I have kept in mind that however much we know about techniques and their application we are lost without our feelings. Feeling is a word with wide boundaries of meaning. One meaning is to perceive or touch, and this without doubt is one of the things we need to do when drawing the figure; we must learn to project our sense of touch, and feel we can touch a subject even though it is removed from us. We cannot draw form unless we have a tactile appreciation of it.

Another meaning is to follow an inward persuasion, and this we must increasingly do if we are to reach the character or essential truth of a subject. If we cultivate our feelings about a subject we have a keen sense with which to judge and appreciate it. Understanding through feeling is just as important a weapon in a draughtsman's armoury as the process of analytical seeing that I mentioned earlier. The two together make art.

The human figure is probably a subject more charged with emotion than any other, for in its many postures it reflects life. If a draughtsman has empathy he is bound to enter the spirit of the subject and the image imaginatively. On feelings therefore I would say never be frightened or put off by them; rather try and exploit and use them, and if there is ever any doubt about what is to be done in the next stage of a drawing return to *feeling the form*.

Drawing as an art is unique in that it interprets a subject on its own terms, and

those terms are the variety of marks that can be made by a drawing tool on a light or dark surface. Three-dimensions are imagined, they are not present; nor is colour or pre-formed pattern. Drawing therefore is the most independent branch of visual art; drawing does not need another art, although all the other visual arts need drawing for it must be part of their experience. Drawing is used in the preliminary stages of graphic work, painting and sculpture, as well as in other fields of design, to develop ideas and test the imagination. Its independent method of using materials provides unique qualities, allowing both spontaneous and economical expression. The *Study of a nun* by Degas (3) is a fine example of the use of these qualities. Certainly learning the practical strategies necessary to execute a figure drawing with movement goes a long way towards developing a command of these qualities.

1 discovering movement and the image

Seeing and identifying

If we had to describe what happened whilst we were making a figure drawing I think one of the things we might say is that we had only been able to identify the appearance of the figure we had wanted to portray because some past experience had provided us with the practice to do it. For drawing purposes this means that we must become practised at identifying a subject in whatever randomly placed or arranged position we may find it. Of these four drawings of the foot (4) only the top right-hand one is characteristic of the shape that ordinarily might spring to mind if a foot was to be presented. It is a 'typical' foot.

But to be able to draw figure movement we must be able to visually decipher any view of any body part. Herman's *Study from the nude* (1) demonstrates this ability. The girl's trunk is in foreshortened perspective and the right foreleg is hidden by the sole of her right foot. In this drawing there are no 'typical' views of body parts. This type of drawing requires that we have made many non-typical views of the figure and stored them in our visual memory. This is what Michelangelo must have done to be able to make the studies of the flying angel (5). The flying figure has been drawn from a combined looking down from above and side views, and Michelangelo clearly had enough visual experience to be able to create the correct appearance of anatomical forms for this position.

To gain this experience some time should be spent with a live model because this will give opportunities to observe so many more views of figure parts. Short poses are very helpful when interspersed with longer ones. Alternatively, it is possible to do a considerable amount of work from photographs provided the analytical approach suggested in this book is maintained.

The world we know is three-dimensional in spatial character and therefore drawing, and its concern with reporting visual experience, needs to be able to communicate three-dimensionally. In learning to draw it is necessary to develop concepts of form which means we must have an awareness of 'solidness' and also the emptiness of space about it (6).

In this study of a man leaning back on his hands (7), Michelangelo has clearly been concerned about the space bridged by the man's arms. It is rendered so well that it is clearly understood that it would be possible for a small object to pass between the man's arms and back. The volumes of the arms particularly are determined by Michelangelo's awareness of them in space and the distance between the hands and the buttocks. Concepts of form and space are somehow 'banked' in our imagination, and it is the imagination which unifies the detail of our sensory experience into simpler forms or images. Our 'banked' concepts of form and space are of use when we view new forms, or quite well known ones seen in new spatial positions. In either case we use a matching experience relating what we know to what we can see until some understanding is reached. The image forming faculty of our imagination assists in the process of identify-

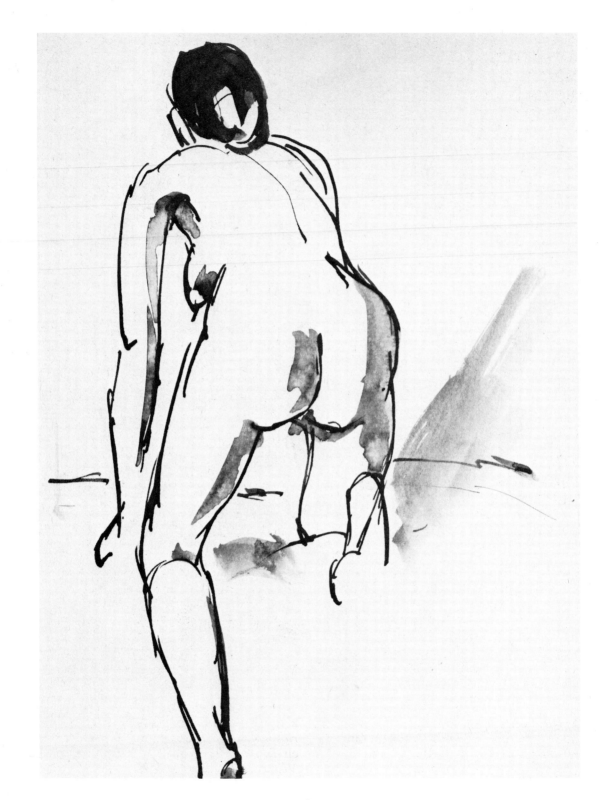

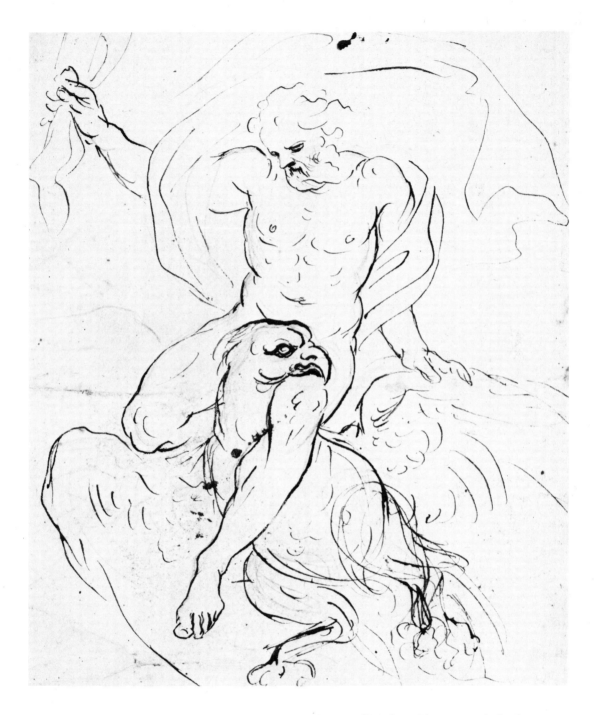

1 Joseph Herman (1911–) *Study from the nude* Pen, ink and wash (226 × 171 mm) *Victoria and Albert Museum, London*

2 Luca Giordano (1632–1705) *Jupiter riding an eagle* Pen and ink over black chalk (394 × 305 mm) *Victoria and Albert Museum, London*

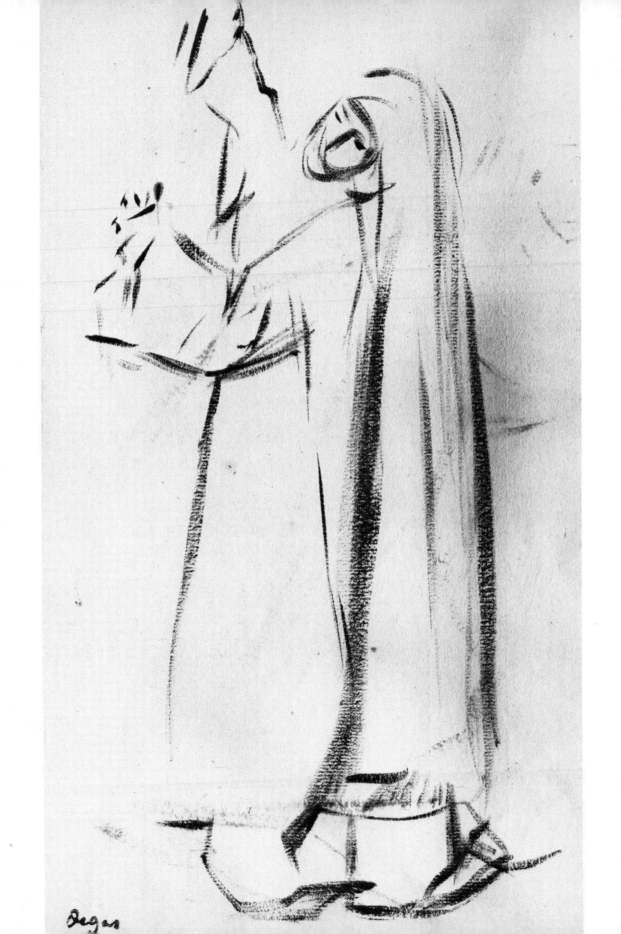

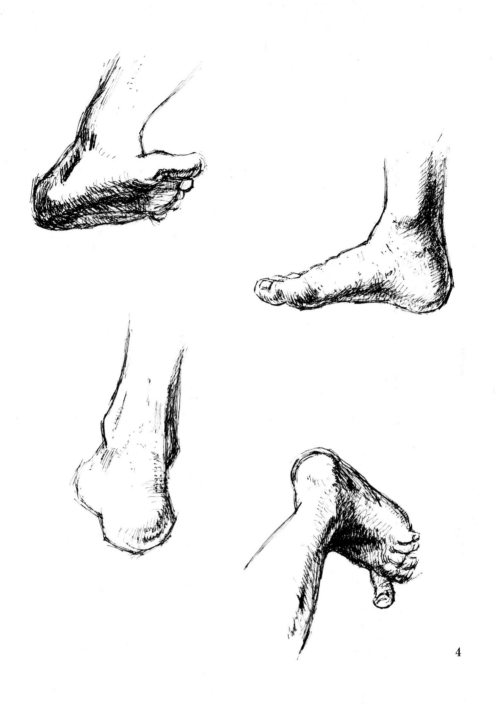

4

3 Edgar Degas (1834–1917) *Study of a
nun* Black chalk (419 × 273 mm)
Victoria and Albert Museum, London

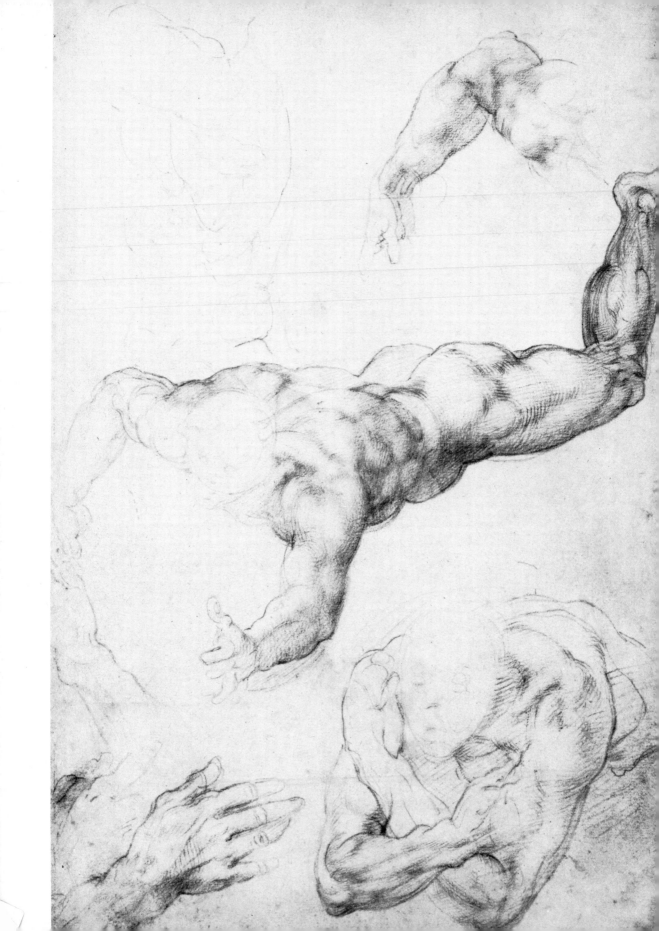

5 Michelangelo (1475–1564) *A flying angel
and other studies* Black chalk
(407 × 272 mm)
The British Museum, London

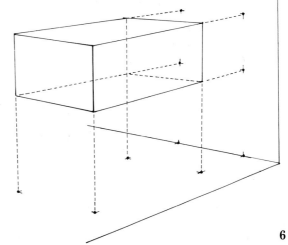

7 Michelangelo (1475–1564) *Study for one
of the resurrected* Black chalk
(293 × 233 mm)
The British Museum, London

6

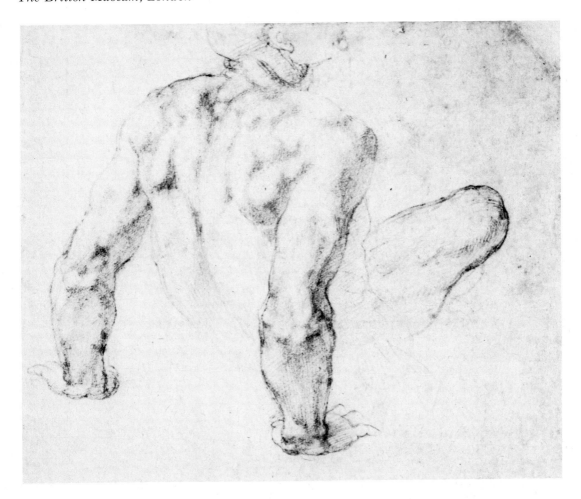

17

ing subjects both from a general point of view and also in the understanding of special features or unusual views. This process can be developed in our formative years and beyond.

The imagination and the non-typical

To draw well our visual knowledge of objects in the world must be fully three-dimensional in character. Perhaps the most important function in a draughtsman is a developed ability to 'see' three dimensional images. First attempts at drawing images by young children produce flat shapes, although maybe with some addition of decorative texture. A young child's drawing is generally calligraphic in nature; that is it adheres to the flat surface, and the addition of shapes which are symbolically representative is spread across the surface until a composition is obtained. Writing and drawing are one to a young child. Boat might be

or Mummy might look like this.

One of the underlying aims of this book is to show that writing and drawing are quite separate sophistications and that to draw well is to understand perfectly the difference between them. A young child produces visual stereotypes when drawing images, the images presenting a limited number of the visual characteristics of an object. A child is not able to absorb and make use of the visual impressions which stream in from the world about. To draw from a variety of natural forms requires an extensive mental manifold, which means that it is necessary to have an extensive visual experience of natural variety. This is one of the reasons why students are taught to carry sketch-books and fill them with countless studies because in this way the visual manifold of the world is explored and registered in the imagination.

The identification of form

Our senses feed us all the time with information that is necessary for our survival and most of it is processed at an involuntary level. However, other information we are capable of receiving goes beyond the necessity of survival, for example our perceptual mechanism enables us to see patterns or significant relationships in natural forms.

The *Two barristers* (8) are real enough although they are only built up by marks in chalk and ink. In the drawing Daumier has communicated the information about the lawyers' clothing by a pattern or series of related marks. To make the marks he has selected what he perceived to be the main features, and has identified both the lawyers' rotundness and gait, and the loose drape of their robes. To be able to make selections from the features of an object we must learn an identification process. The practical use of this process in drawing is explained in chapter 3.

This early stage of a figure drawing (9) shows how marks have been used to identify selected positions on a model. The drawing would be completed by more and more identifying marks being added to it. In theory the process of identification and selection needed to make marks and start a drawing are much the same for everyone. However the mark making process after identification is highly individual and it is the individual differences that create stylistic differences. Of course identification for a draughtsman can go much further than making a pattern of

8 Honore Daumier (1808–1879) *Two barristers* Sketch in chalk, red and black ink (231 × 184 mm)
Victoria and Albert Museum, London

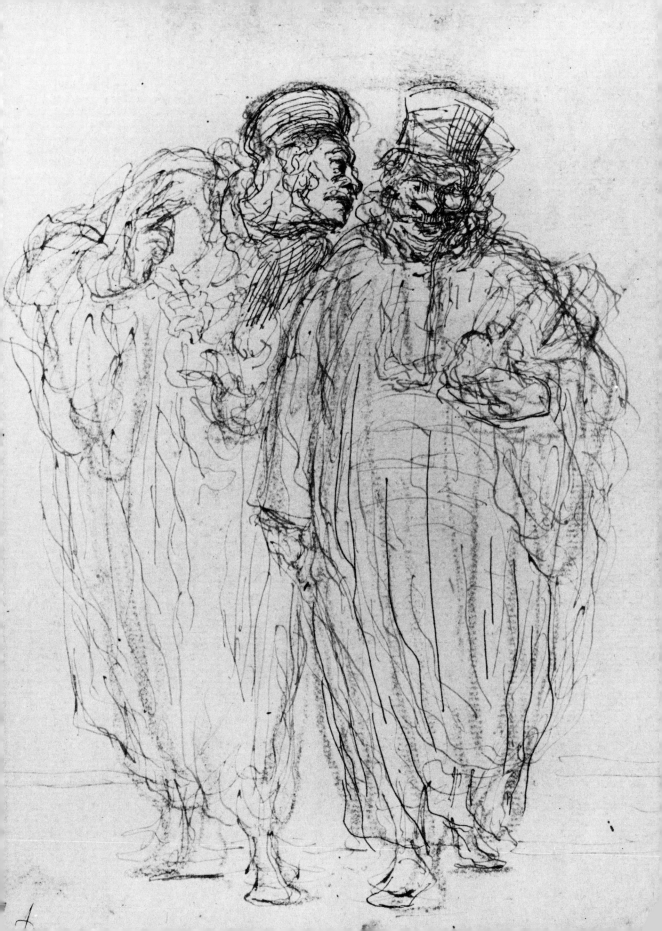

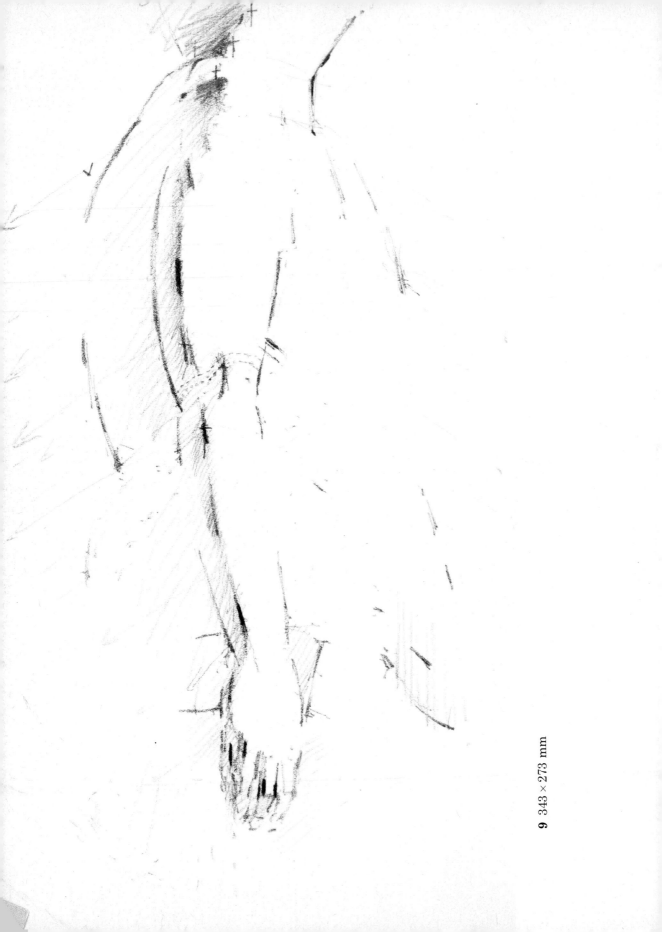

9 343 × 273 mm

marks. Marks become a nuance that is to say they are built up to express sensations of surface, texture and direction and volume. This life drawing study (10) has been taken much further than the previous one and it can be seen how with the addition of further marks, nuances of tone and modelling have been obtained. The *Man fleeing in terror* (11) is a very complete academic study of a nude. Modelling and contours are fully established throughout. The first pattern of marks are concealed by many additional marks that have been used to give form to muscles and body parts. The sensation of the weight of body parts as well as their position in space has been well felt and recorded. At the edges of planes in shadow nuances have been built up that are necessary for the understanding of any particular form section.

It is certain that the more concrete a subject becomes in terms of our sensations, the more we have empathy for it and identify with it, and it is in this way that a drawing comes to life. At some stage of a figure drawing we may even 'act out' in our imagination the figure's position and its meaning, and believe in its reality. The drawn image can have no real existence unless our own bodily attitudes have been involved in its making. When drawing is truly creative the draughtsman fulfils his own sensations, going over the subject repeatedly in his mind so that all its perceptible movements have found sympathy with his own habits of action. The whole mind is lost in the subject. In the *Serving man* (12) Watteau shows great depths of personal identification and emotional involvement with the hurrying servant. Technically, because of its simplicity and correctness of marking, it can be much admired. And in any attempt to describe its greatness the deep awareness of the meaning of the movements of his subject could not go unrecorded. This depth of identification or emotional involvement will become clear to anyone who continuously practises drawing figure movement, and also we shall realise that although we may start objectively, we will discover after the drawing is complete that during our involvement we have distorted what we saw. Hopefully, this could be a bonus, and we will have stressed and extended a valuable aspect of the subject.

Blake's *An angel striding among the stars* (13) is a personal explosive view in which the artist's involvement and imagination has moved him to expand beyond the more everyday objective, presentation of the human body. It could be an inspiring drawing for those who wish to use the drawing of human movement for dramatic graphic effect. Matisse once said that 'a painter doesn't see everything that he has put in his painting'. The same with drawing and drawing figures in action. With imagination aroused we may not at the time see all we have put into a figure action. Involvement is everything and it is only afterwards that we can see what we have done. As Blake shows, drawing is not only a matter of 'seeing' but a process that engenders the passionate arousal of a draughtsman's feelings.

Movement across the form

Sensations of form, the ability to 'feel' it, develops from use of drawing marks made to represent solids. The sensations are deepened by a build up of marks which are used to make clear the variation in the direction of the different planes seen in the subject. It is the kind of drawing experience that takes place every time we attempt to draw a cross-section of any part of the human body.

Observe how Michelangelo's marks in the torso of the seated man (14, 15) differentiate the plane directions that make up the body surface of his subject. The marks are placed turning away from the light and they are used consistently to construct the superficial muscle groups as well as complete cross-sections of body parts. If any section is followed we become aware of inclined and

11 Raphael (1483–1520) *Man fleeing in terror* Black chalk (318 × 257 mm)
By gracious permission of Her Majesty the Queen Royal Library, Windsor Castle

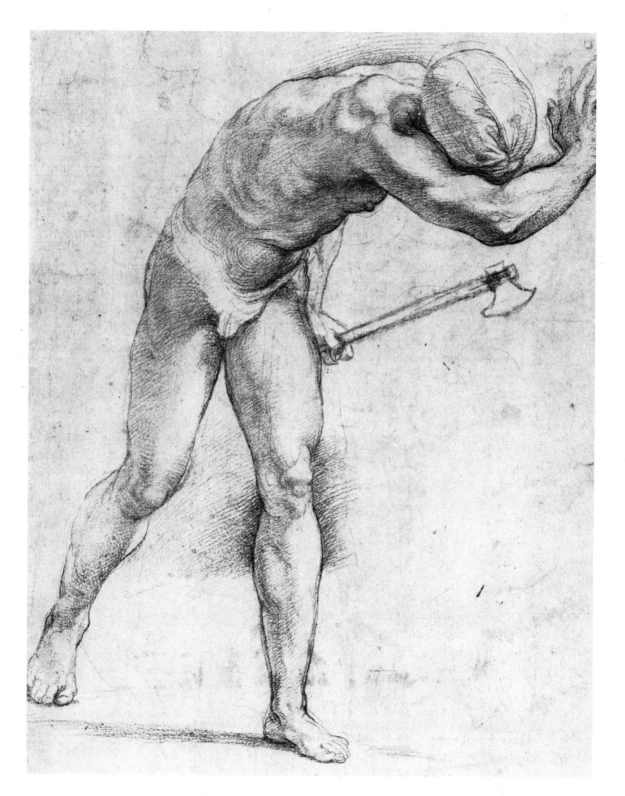

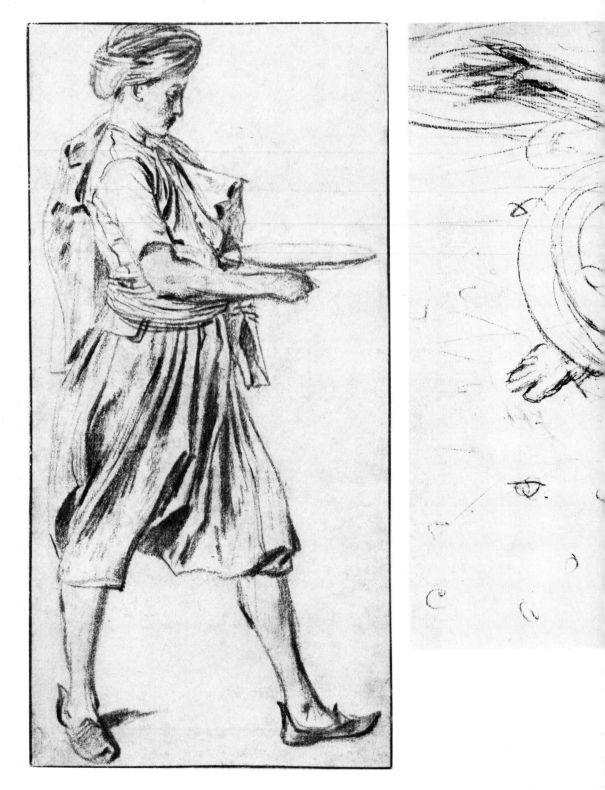

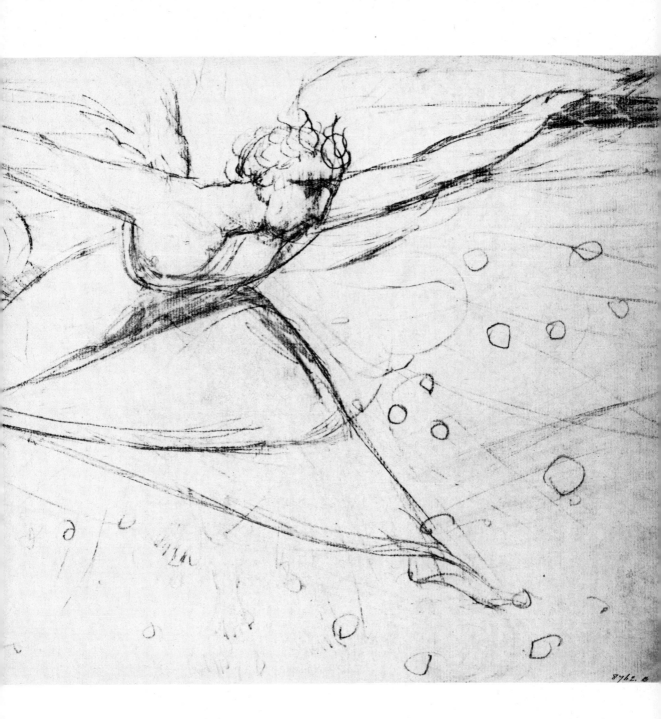

12 Antoine Watteau (1684–1721) *An oriental servant walking holding a plate* Black pencil, conté-crayon, black and red chalk (201 × 101 mm) *The British Museum, London*

13 William Blake (1757–1827) *An angel striding among stars* Pencil (273 × 405 mm) *Victoria and Albert Museum, London*

25

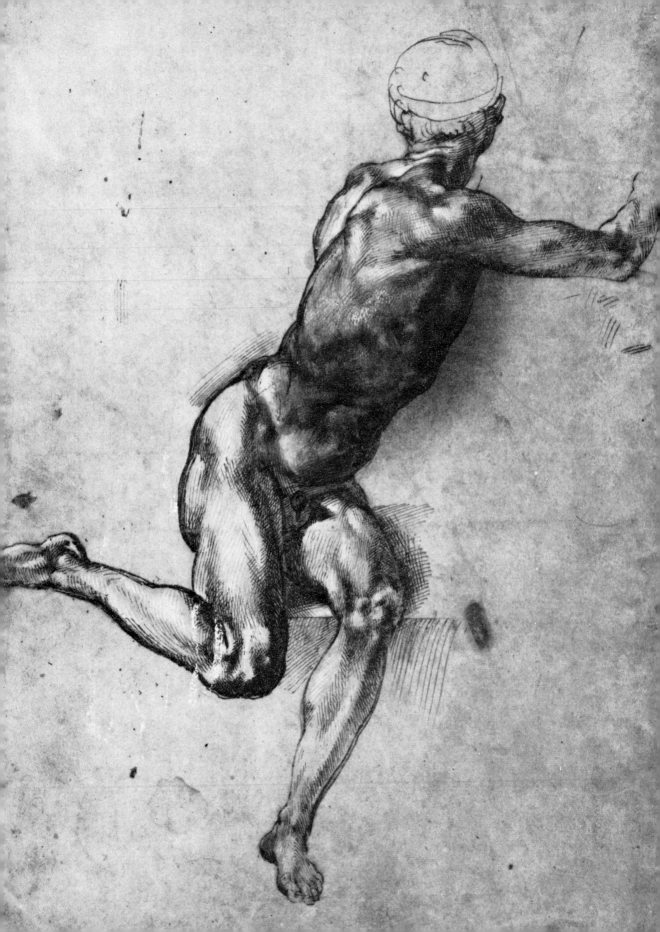

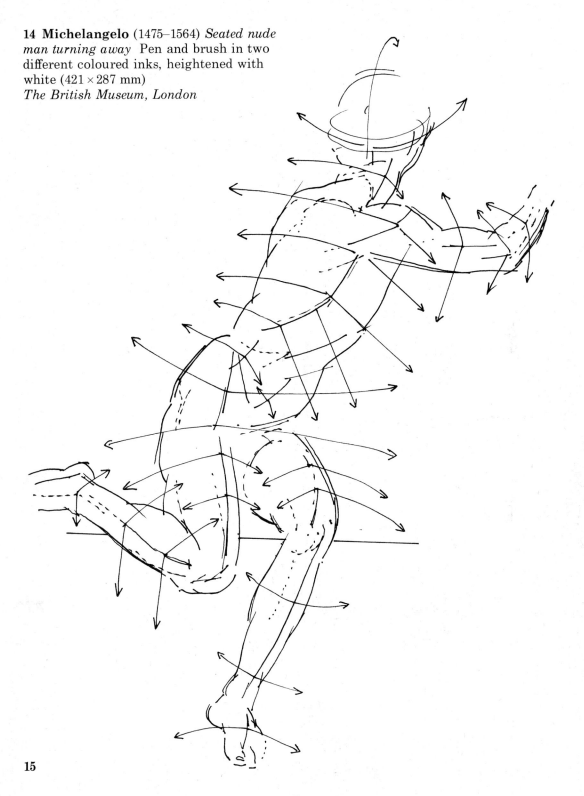

14 Michelangelo (1475–1564) *Seated nude
man turning away* Pen and brush in two
different coloured inks, heightened with
white (421 × 287 mm)
The British Museum, London

15

dipping surfaces, in fact we 'feel' the form. The inclines and dips give a sensation of movement, and one of my aims is to show that it is possible to learn to express movement by first feeling the movement made by changes of plane across a form.

There must be a certain consistency in the build-up of marks throughout the drawing as it develops, for they must also maintain a unity of effect. Bandinelli's pen drawing is a good example of this (16). Compared with the previous drawing by Michelangelo this has certain obvious weaknesses: knowledge of human anatomy is poorer and identification with the subject is slight, but nevertheless, the unification is effective with the light planes preserved to make a stimulating visual effect on their own. The other studies on the sheet are well worthy of study, in them marks are used richly to 'feel' change of shape in body forms.

I chose the next four drawings so that there could be an extension of the discussion about feeling movement across the form and how this enabled a draughtsman to become aware of the movement in a figure as a whole. In both the Cézanne (17) and the Maillol (18), the artists are depicting stationary figures, yet their techniques endow the figures with a lively quality which suggests that they could take up another position at any moment. This has been largely achieved by powerful form feeling by section. Cézanne has built his marks into heavy nuances wherever light planes are bounded by shadow and these have been continued to express change of direction across the form. The shadows against the light are formed into contours that have a strong rhythmic nature and which have been felt in their conception to relate to the curves of the outside edges of the forms. Wherever one looks on the drawing it can be seen that these three contours together always suggest life and movement. The Maillol does much the same thing, although the technique is lighter and there is no nuance between light and shade planes. However there is a very clear understanding that there is a sharp change in direction of

the form surfaces, and the movement felt is beautifully illustrated by the firm but delicately repeated directions placed across the spine and the back of the legs.

A moving figure treated in conception by the same technique will appear very lively. Filippino Lippi in his beautiful drawing of a nude man (19) has used his anatomical knowledge to help him feel the movements across the form. Nuances which form shadow contours turning away from the light have been built up to express movement round the form. The combined effect of this treatment throughout the figure is one of great animation. The movement across the form gives life to the muscles and enhances the kinetic quality of the pose. The fourth drawing depicts a most transitory movement. Toulouse-Lautrec's dancer (20) is balancing on one leg, different parts of her body pointing in different directions in space. In this wonderful drawing the highly sophisticated technique tends to conceal first thoughts and constructions. The modelling on the supporting leg indicates how Toulouse Lautrec went about feeling round the form. The use of contours derived from light and shade is the same in intent as in the previous drawings. Here a feeling for form has developed into a feeling for space, which is incorporated as a positive part of the image. For example the two arms have been seen together as boundaries to a plane of space between them; they have been felt in relationship to the plane direction of the ground (marked out in clear perspective lines) and make us aware of the space the dancer is moving in. (The idea of feeling both form and space as a technical device is examined in chapter 3).

16 Baccio Bandinelli (1488/93–1560)
Studies of nude figures Pen and bistre, slightly washed with Indian ink
(423 × 260 mm)
Victoria and Albert Museum, London

17 Paul Cézanne
(1839–1906) *Male nude*
Charcoal heightened
with white on laid paper
(490 × 310 mm)
*Fitzwilliam Museum,
Cambridge*

18 Aristide Maillol
(1861–1944) *Women undressing* Pencil, with some rubbing, on ruled off-white wove accounting paper 349 × 226 mm)
Courtauld Institute Galleries, London

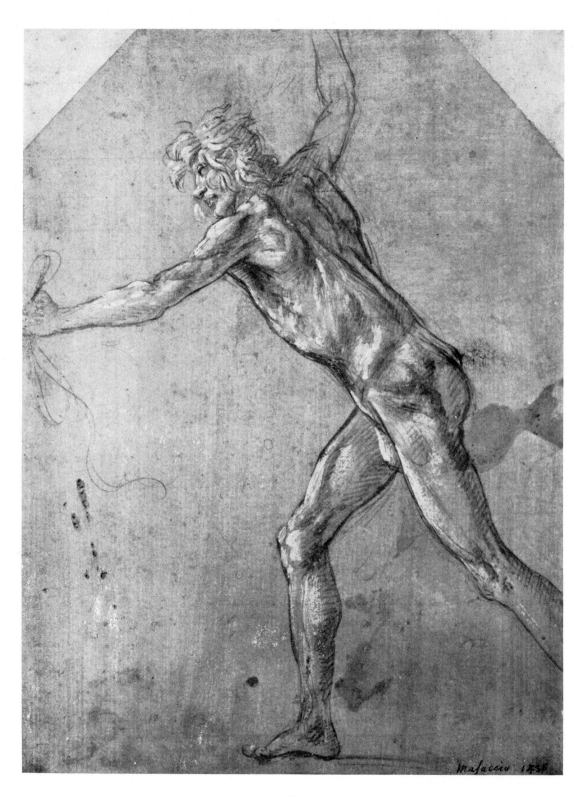

32

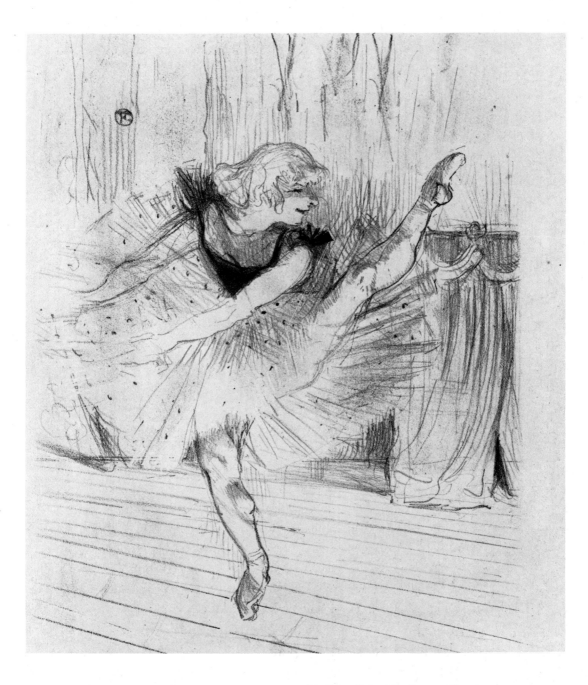

19 Filippino Lippi (circa. 1457–1504) *A nude man* Metal point on mauve-grey prepared surface heightened with white (236 × 177 mm)
The British Museum, London

20 Henri de Toulouse-Lautrec (1864–1901?) *Miss Ida Heath, Danseuse Anglaise – English Dancer* Lithograph printed in green ink, crayon with scraping out, on off-white wove paper (375 × 279 mm)
Courtauld Institute Galleries, London

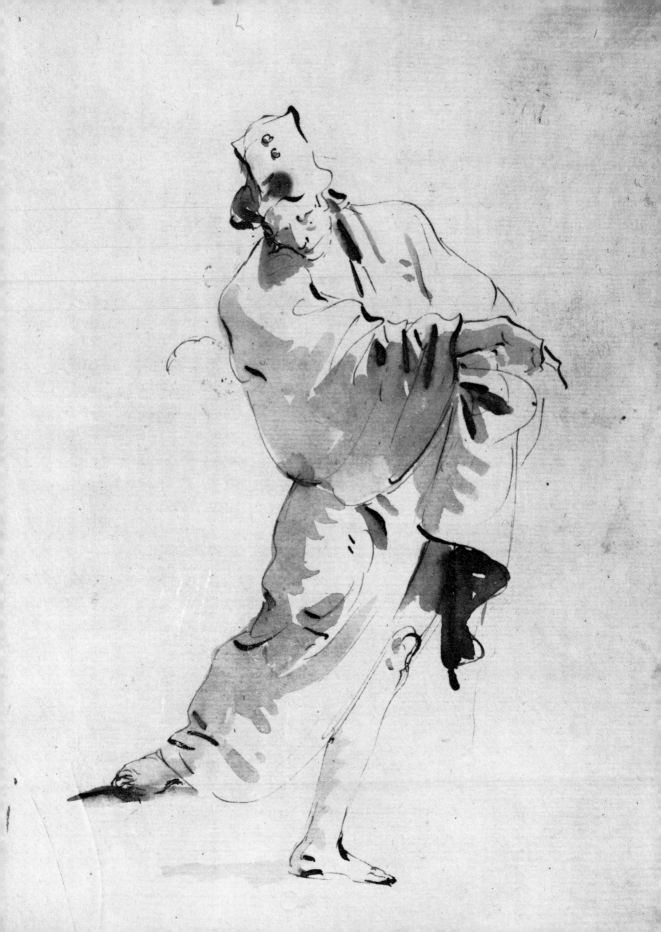

The imagination and the image

To be able to create a vivid impression of movement in a drawing we have to combine the processes of looking, thinking and feeling. It is the successful management of this combination that will give a draughtsman's approach vitality and allow him to express his imagination and energy. Santayana writing on visual art said – 'the artist is singularly sane for everything must pass through *his* senses' but, *'life, whatever its complexity, remains primarily a feeling'*.

The first marks a draughtsman makes match certain proportions and directions, the marks are then considered and re-adjusted and as this takes place *feelings arise concerned with form and movement*. Tensions are felt between markings which are re-intensified. As the drawing proceeds the imagination co-ordinates the feelings derived from the subject and the growing image, this in turn encouraging re-marking and the use of emphasis. So drawing is very much a selective process governed by our feelings and imagination. Tiepolo's *A man in a cloak* (21) accomplishes this process. It can be seen immediately that this is a highly selective drawing. Nuances created by emphatic re-marking in pen emphasise the direction of form movement as well as the form itself. They also show the pull and fall of the materials of the cloak on the body parts. It can be realised how his first marks must have indicated general directions of movement, and the pen mark emphasis shows how tension developed and the artist's feelings were stimulated. Although this is a completely understandable drawing of a man, it is executed by the briefest means, and the success of its style owes everything to the clear thought, powers of selection and use of the imagination of the artist who made it.

The artistic possibilities of a subject are

not labelled on it, and that is why the selective process is so important; it is merely the provider of forms and ideas. The draughtsman's imagination determines the appearance of the final image. The imagination collects and rejects ideas in the course of a drawing's execution. The draughtsman, of course, often has to struggle with his technique to express these ideas. They do not always come easily. In Daumier's *Two barristers* (8) there is evidence of Daumier's struggle with ideas which produced a beautiful effect. Daumier has gone over the lawyers robes in chalk, and in two different coloured inks, to express the animation he was after. The robes' execution is entirely his own invention stimulated by his imaginative ideas on how cloth of a certain weight might drape and move.

Where is a subject's interest?

It might be asked what it is that makes an artist think of a subject in a particular way, or what it is that gives an artistic interest. When drawing one cannot act as a camera. A drawing does not arise all at once instantaneously as it were. Some marks preceed others. The marks are selected by the artist, their size and where they go on the paper. They are initially selected quite consciously because in the beginning a drawing requires some element of planning. From what they are selected, the priority in which they are put down, and what they represent, is discussed in the next chapter. To see a subject we have to scan it, and when drawing, work in relation to this scan; and whilst scanning we become aware of a number of things which have to be made clear. So a drawing has to be built up in a period of time, whereas a camera produces one image from another instantaneously. Whether one has an artistic interest in a subject is therefore very often beside the point, because the practical necessity in drawing is first to understand what is seen and then be able to carry out a process of mark making in relation to this. To draw movement requires the same understanding and process.

21 Giardomenico Tiepolo (1727–1804) *A man in a cloak bending to left* Pen and wash (267 × 193 mm)
Victoria and Albert Museum, London

It is however true that an interest in artistic questions, an interest in what other artists have found in their subjects, does give us a much deeper appreciation of drawing artistry, and of course, it is because of this fact that I have selected drawings for this book for source material, and for their use as visual aids to help towards a better appreciation of drawing technique.

A sense of beauty is waiting in all of us to be developed. But we cannot take a sense of beauty to a subject and hope that it is a tool that will somehow reproduce itself. The sense of beauty is in our perceptual understanding and between it and our subject we must place a technique to act as a bridge. This is the practical necessity. So that whether a subject possesses beauty or not amongst an artist's first considerations. What we must possess is a desire to draw; it will suffice even if the desire is not too strong for with practice it will grow.

The need for a pattern and positional marks

You may have already found that there are quite a few ideas about how to make a drawing. As a young student I was confused by the variety offered. The concepts which I find helpful, and use myself, are partly derived from one 'school of thought' I met in my student days, and partly from what I have learnt by teaching life drawing. They are built round the notion of starting from positional marks on the paper which relate to features of the subject. The features to which the marks relate are ends of planes, or surface change of direction, which are revealed by light and shade. My start at a life drawing (9), shows how to go about this process. In this kind of approach it is a matter of going slow in the beginning to go more quickly later. In the early stages restraint is shown whilst distances and directions are examined and re-examined in the subject and marked down on the paper, and a pattern state is achieved by a particular disposition of points and lines that can be further modified and enriched.

The pattern must contain *three-dimensional concepts* although by how much is determined within an individual drawing style. There is not a completely set procedure for this. That is to say there is not just one place on the human figure that should always be considered a starting point, although after a time one does acquire favourite starting places. Yet there is a procedure of a kind which provides the shortest path towards unravelling a figure subject in terms of form, space and movement. The gestalt theory in psychology offers a means of understanding and perceiving this, and a method by which we may determine our first pattern when we start a drawing. The practicalities of this method will be examined in the following chapters. The start shown in (9) would be the beginning of a protracted drawing, and it is in more lengthy type drawings that the method is learnt. Nevertheless the same method is used for far more rapid studies and it is then apparent how justified the method is.

There are variations in style in the pattern approach. A more summary form of drawing, less objective at the outset, offers a condensed method of working. The *Study of a female figure* by Gaudier-Brzeska (22) is such a drawing. The shadows, although stated starkly, are briefly noted and rendered in shorthand form, and instead of being used exclusively to model the figure forms they make a decorative design full of movement.

Theory and practice

It is not possible for a human being to be successful as a theoretician and a practical exponent of an art simultaneously. I first learnt this as a student from a remark I heard attributed to the French painter Corot who said 'when I paint I do my best', which could easily be accurately transcribed to 'when I draw I do my best'. A wonderfully revealing remark in which Corot is saying very clearly that theory and practice don't mix, and that the time for theory is in between our practical efforts. There is then a time to visit galleries and museums, a time to look at

drawings, a time to study, and it is a very important time in a creative person's life. It is a time to stock up ideas, techniques and impressions, a very necessary time in which to enlarge and enrich one's visual memory bank. Between drawing we give lots of time to thinking about our work, the techniques we use or might try, about how ideas arise and about the development of new techniques. But *when you draw you do your best*, and you may be sure that all your theorising and thinking about other artists' work or your own will not be lost but lurking in your subconscious to come out and feed you in your struggles. There are of course moments when drawing when we need to think as well. I do not believe that drawing skill is a gift that you have or haven't got, and is dropped into your lap from heaven if you have. I don't believe it is as simple or as dull as that, although undoubtedly we have personal gifts, things we can do more immediately with facility better than other things.

Drawing – thinking or feeling?

The moments of thinking when we are drawing probably split into two. There are moments when we need to stop working on our drawing and get back from it to consider and think about it as a whole, and there are the working 'thinks' when for a fraction of a second we think about some aspect of our subject or our technique. It is necessary to think in mini-seconds about an angle or a proportion and then go on and 'feel' the consequences of what the 'think' gave us. A drawing is a summation of 'thinks' and 'feels'. It has to be learnt that these two things cannot be done simultaneously; rather they are mutually dependent on one another. It is fatal to good drawing practice to muddle 'thinking' and 'feeling' together. Fast and furious drawing may seem to make

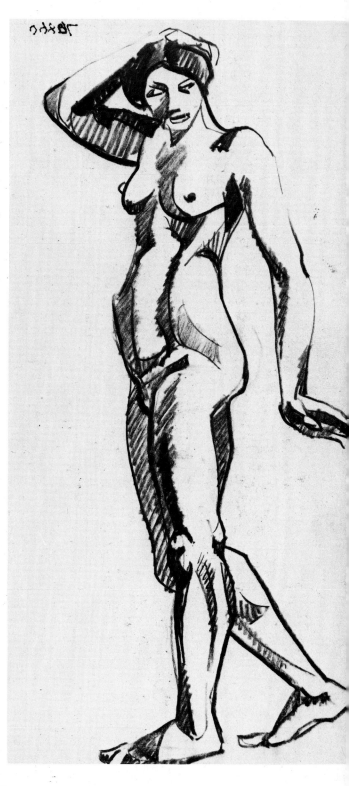

22 Henri Gaudier-Brzeska (1891–1915)
Study of a female figure Charcoal (508 × 381 mm)
Victoria and Albert Museum, London

them come together, but the reality for the beginner is that they are separate but mutually enhancing. I have seen many students of drawing develop from beginners and watched their steady progress over a number of months after I have taught them to 'think' whilst they draw and '*what* they should *think* about', and to 'feel' and about '*what* they should *feel*' about. Once the interaction between thinking and feeling is understood and used, there is a steady and noticeable increase in drawing fluidity.

I do not believe there could be a more fitting drawing to discuss and end this first chapter than Cézanne's *Male nude* (17). The drawing was done in Paris where he had gone to study in his middle twenties. Like so many drawings done by students in the life-room this is a positive effort by the growing artist to use his powers of analytical drawing to construct figure forms by the use of light and shade, but at the same time attempt to 'feel' the dynamic quality of the parts as well as attempting a general effect with which to sum up, for it can be appreciated that his imagination moved in at some stage to catch the over-all image. The final simplicity and fluidity is both powerful and moving. Maybe to the absolute realist the imaginative faculty may have been allowed to move in too early so that the thinking out of the trunk proportions in relation to the legs was not allowed to proceed long enough in time to produce a so-called 'correct' result. But are

we to judge this superb drawing from this standpoint; thinking, feeling and imagination can all be seen to have been employed and the drawing is a monument of its kind. One could reasonably conjecture that at this time Cézanne was beginning to face up to his own feelings, and began to understand with the help of the museum studies, where they might lead him. We know his work was considered awkward by others and he was to some degree isolated, and it is worth remembering that he would have been surrounded by students drawing the nude in a highly representational Victorian manner. When Cézanne drew this figure he did his best at that time to present an image which gave him satisfaction and which developed still further in him the power to unify thought, feeling and imagination.

There are moments in creativity when you only believe in what you feel, the feelings give rise to a personal expression and the individual style and image is born. Creation through feeling however is not possible unless the artist has given thought to what he can see and touch. Each one of us has to get the balance right between these two things. Cézanne's drawing is a fine example to a beginner of what must be attempted in the early stages of learning to draw. Its idiosyncrasies of proportion serve to remind us that drawing is a creative art and that our feelings will take us beyond mere mirror representation.

2 drawing marks and how they are used

Definitions of drawing

Definitions of drawing are many and varied and an artist talking about what drawing is will speak in relation to how he sees the usefulness of drawing at a particular time. Some of my favourites which I hear myself using time and time again in teaching are: Seurat: 'drawing is the art of hollowing out the paper'. De Segonzac: 'no one can draw who cannot draw the pose of a man about to commit suicide by jumping from a window sill before he hits the pavement below'. Velasquez: 'give me a dirty boot and I will draw anything you like'. Matisse: 'drawing is putting a line round an idea'.

When we are drawing, all we have to use are marks of some kind on a white or toned surface that will take them. These marks range from small dots, ticks, lines and areas of tone to increasingly larger versions. Generally, but not exclusively, the larger scale of marking is reserved for the larger sized surface. Tones are produced in countless ways, by cross-hatching, by stippling or in some more liquid way with a brush and wash. Individual expression gives rise to an endless permutation of making effects often by the combined use of several mediums.

Watteau's *Walking oriental servant* (12) is drawn in black pencil and conté crayon, but the pantaloons, jacket and face are touched in with red chalk, and the turban with black chalk.

In Daumier's *Two barristers* (8) black and red ink are combined with chalk.

Any definitions of drawing we may find are only useful if they can help us with the business of making marks and lines and stating visual ideas on paper. My favourite definitions do just that for me, and have helped me many times to explain to students just what one is up to when drawing.

The paper is hollow

Seurat's: 'drawing is the art of hollowing out the paper' has always seemed to me to put the cat amongst the chickens. It tells one right away that there is a striking difference between writing and drawing. When writing we use a paper surface as a tablet on which we place letter symbols from left to right. By our middle teens most of us have built up a series of conditioned reflexes and responses that relate our brain function to the mechanical function of the hand, so that we can write without being unduly conscious of the process. This is a tremendous feat in itself and one of the great tools of generation education, but it is of little use to us if we wish to draw; in fact I have come to believe it is a positive handicap. Seurat, as any artist must, had noted this. Thus he says we must 'hollow out' the paper. So it is with this totally different and radical philosophy in relation to writing that we must approach the paper if we wish to draw. We must believe the paper can be 'hollow'. Quite a cheeky imaginative feat in itself. The paper surface is the picture-plane which we use to look through to see into the space beyond, a space bounded by the frame provided by the edges of the paper. All form and form movement we create is created in this space beyond the picture plane. All the drawings you can see in this

book exist in this imagined space, although it is true in many cases the space is very shallow indeed. It is also true that with the historical progression of drawing skills, and the meeting together of many drawing ideas from all over the world, greater use has been made of the drawing surface or picture-plane to compose on allowing the reiteration of mark making in two dimensions. Nevertheless Seurat's remark stands to remind us of the change in mental attitude that is needed when we draw. We must return to this remark when we look at practical solutions in the next chapter.

The marks

Velasquez's remark: 'give me a dirty boot and I will draw anything you like' will always remind us that however clever one is with one's hands in producing beautiful effects, they will appear merely flashy if they are not supported by clear and apt thinking. I have heard it said that the Japanese artist Hokusai, renowned as a draughtsman, used to invite one of his students each morning to give him some unlikely piece of material to draw with; a rough piece of charcoal or a thick stick dipped in ink. Each time he rose to the challenge to produce a striking drawing proving that however coarse the mark made by a particular medium, it was the manner in which the marks were related and composed that made the drawing. Velasquez's remark suggests that it is possible to draw with anything that makes marks, the quality of the mark matters little but the composition of the marks matters a great deal. In becoming proficient at drawing movement it will be found that the composition of one's marks is crucial.

Ideas and lines

The remark by Matisse 'drawing is putting a line round an idea' is open to misinterpretation but if pondered on will produce more good results than ill. Unfortunately, the tendency in starting a drawing is to bound the subject being drawn with a contour line. This is done unthinkingly and is possibly connected with the difficulty of converting from writing skills to drawing skills. If we think about what Matisse says, we can be helped through this difficulty. Ideas he puts first, drawing lines come second and it is, he says, a drawing skill to place them round ideas. Drawing is concerned with solid form, forms that have height, depth and breadth, so our lines in drawing are put round solids. Drawing then is firstly having an idea or ideas about solidity, and then secondly putting a line or contour round it. I often say, when teaching drawing, 'the outside edge is the result of the inside form', which is saying the contour line must be an expression of the type of solidity that lies inside it. Before we can draw in pure contour, we must learn a method of analysing and understanding the type of solidity that lies inside the lines we use.

If we look at the lithographic drawing *Le jour* by Matisse (23) we can understand what he means. It is a pure line or contour drawing, yet all the forms of the woman's body are well realised and stated three dimensionally. The breasts are on the front of the chest wall, and it can be seen that the chest has depth; this is implied by the position of the nearest breast in relation to the contour for the rear of the chest. The tummy can be touched in our imagination, it too has a front and side. The bulk of the thighs is well realised within the contours used. So here is a very solid figure expressed in line. Quite magical, and please don't forget this point, owing everything to the well modelled drawings that Matisse did as a student which enabled him to build up his ideas about form and form movement in drawing.

Drawing in the mind

Finally the Segonzac's remark: 'no one can draw who cannot draw the pose of a man about to commit suicide by jumping from a window-sill before he hits the pavement below' is well worthy of thought and study, and perhaps the remark most suitable for our continuous attention bearing in mind the subject of this book. It is a remark that will never outgrow its usefulness. You will no

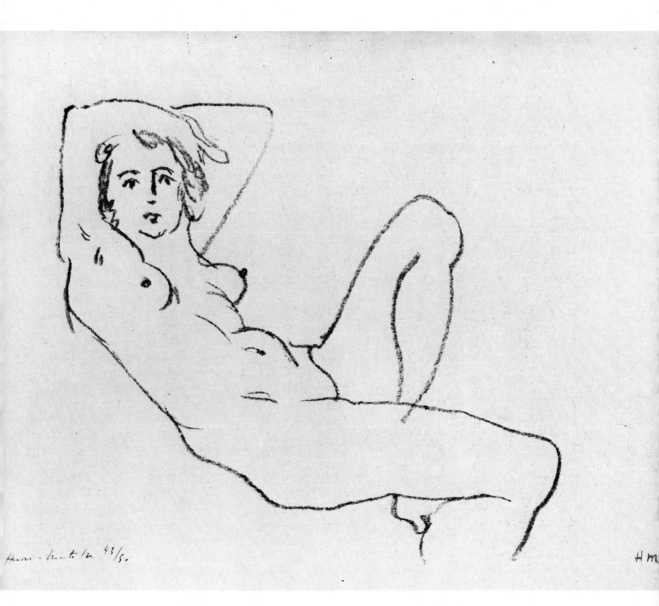

23 Henri Matisse (1869–1954) *Le jour*
Transfer lithograph: crayon, printed in
black ink; on white wove paper
(280 × 449 mm)
Courtauld Institute Galleries, London

24

practise at putting certain things before others if we are to do this. There must be a rigorous simplification process at work in our minds and it is a process which has to be learnt. The Seconzac's remark reminds us of this. To draw figures well and to draw their movement, we must be able to grasp the 'form movement' of their parts in space by the simplest three-dimensional concepts possible. Details of eyelashes or buttons or other trifles, must all be excluded until only the main architecture is left. You couldn't put the buttons on a man's coat committing suicide by jumping from a window sill before he hits the pavement below. You couldn't note his shoe-laces. Indeed literally you couldn't draw him at all on paper in that time. But, and here's the trick to be learnt, you could draw him in your mind, you could form and space-plan him in your mind, you could, and this is what we have to learn to do, create a mental concept of him as a piece of three-dimensional sculpture. I have made a rapid sketch of the simple structure of a man jumping which is based essentially on a number of box-like forms (24), some sides of the 'boxes' are parts of the man and some are the spaces between parallel limb parts. Three-dimensional thinking of this kind is invaluable when drawing and it is this form of drawing that Segonzac is saying can be made *in the mind*.

A colleague said to me once, '*all my best drawings are in my mind*'. If you can do good drawings in your *mind*, sooner or later they will find their way onto your paper. Whenever you start a drawing of a figure in movement try to see the whole action in your mind in the simplest of terms as I have shown in the diagram.

I have found it useful with my students to arrange very quick poses with a model and encourage them to draw down rapidly the essence of the mental concept they first saw, teaching them at the same time about the essential statements of formal space that must be included in these concepts. And when I am teaching the process of seeing and analysis from a three or four hour pose, I

doubt have discovered, and we shall see in the next chapter, that we can only build up a drawing by parts, each part needing a number of marks to express it, because there is no magic process that allows us to make a drawing all at once. This often means that when drawing by the part we loose sight of the whole, or we forget the composition of the whole image in our struggle to get one part right. This does not only happen to a student but to the most expert of us. We must always be on the alert for an understanding of the composition of the whole image. If we wish to attempt to draw figures in movement, we certainly must at some stage in our drawing be able to have an overall view of all the parts of the figure in action and realise how they relate to one another. We must

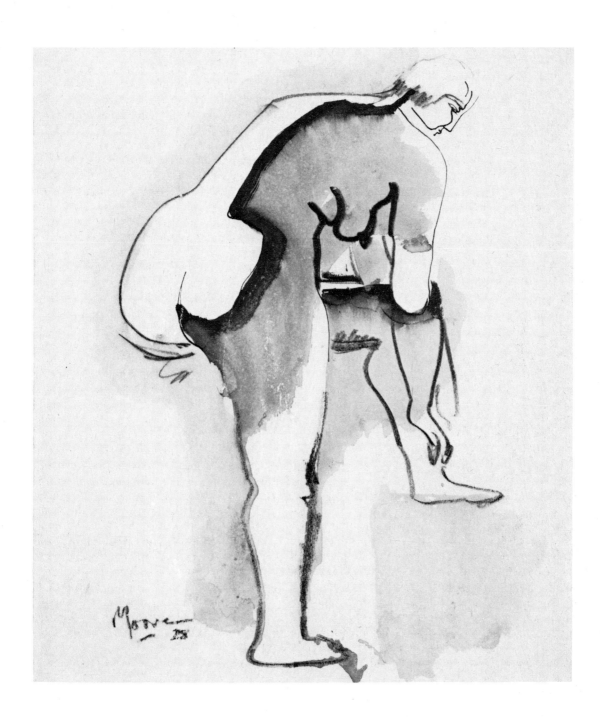

25 Henry Moore (1898–) *Standing nude*
Pen and ink, chalk and wash
(375 × 317 mm)
The British Museum, London

often remind students of this instant realisation of the essence of a pose which we must be capable of grasping at all times. The extraordinary powerful inside contour edge drawn in chalk and wash in the Henry Moore *Standing nude* (25) would not have been possible or so expressive as a summary inside contour marking of the angled trunk, if Moore had not had an overall realisation of the three dimensional structure of this pose at some stage in the drawing. It is *the total realisation of the structure of a pose which enables us to express our feelings about its form and movement.*

What has just been said does not mean that a drawing is inflexible. Drawings will change as you carry them out, and the changes will reflect your realisation of the structure of the changed pose.

Drawing the selective process

It must be realised that drawing is not a process of producing a magic photographic image by an immense natural talent or an acquired one, nor is it a process of producing a form of realistic image that could compete with the realism of the film or television.

A camera can capture in one instant a total effect of form in light and shade, it records a whole subject impartially within the field of its pre-set mechanism. In one operation the camera exposure will represent a form of truth about a subject that exposure time, light, lens quality, and focus, etc, allows. It can do no more. It cannot make a personal judgment about the image it is recording and make varying adjustments to the recording of *tones, directions and nuances* across the picture surface to produce some 'felt' effect. A camera cannot feel and select in one shot. Our selective vision allows us to focus on things in a scene, remember where they are, then focus on something else, and finally, if we wish, bring the parts together and make a relationship between them. We personally make clear some aspect of a subject to ourselves; to recognise we identify features and relate them together.

Even in a quick drawing a draughtsman

has many instants at his disposal. Only so much can be selected and drawn in an instant, and to leave the drawing intelligible at any stage should be the constant aim. The draughtsman must decide what will be selected and stated and how it will be stated. A point, faint or dark; a blob or a sharp direction and so on. One instant spent in part of a drawing precludes it being spent elsewhere. In using up his instants, a draughtsman has to practise a very sharp and apt sense of selection as well as an apt sense for the type of marking necessary. This is a very personalised process.

When drawing from a subject the question that must be asked is 'what is the simplest structure that will serve my purpose'? Each fresh subject raises the same question. Constant practice will gradually lead to the clearest technique for simple structured drawings.

Finding a theme

When we learn to draw we must spend some of the time learning where to start, or how to start. Each draughtsman will develop personal habits for this. But in the academic sense some sorts of start are better than others. Certain features can be focussed on before others. How this may be done will be discussed in the next chapter. A drawing once started will be built up by a collation of instant impressions of chosen features and bound into an image. A successful drawing will show by its choice of positional marks features *what are* the essence of the subject as the contour in Moore's standing nude did. The marking out of the essence of a structure is generally the beginning of a thematic view of the subject. The thematic development of a drawing is to some extent habitual and displays the 'hall marks' of a draughtsman's style.

A drawing 'works' if its marks convey some thematic material. Thematic in an abstract or technical sense and not necessarily in a representational sense. Marks in a drawing will be aimed to convey form and space and movement and to put across an

impression of this by the simplest means. They therefore need to be coherent in terms of form, space and movement from the beginning, degrees of representation or realism being reached later.

Creating the metaphor and using shadow

Although drawing marks are structural, they are also highly metaphorical in the best draughtsmans' hands. A complex drawing by Michelangelo may be analysed in terms of mark placing and be shown to contain certain essential visual metaphors which undoubtedly moved his imagination when he made them and which can now move the imagination of a viewer. His metaphors are concerned with form and movement and have a highly abstract basis, although the drawing may be recognised as a fine anatomical rendering of a powerful man's physique.

I use metaphor in the sense that it is a device that enables us to convey very briefly, but at the same time vividly, ideas that could be explained in other forms but which might be tedious. So when I say that a drawing is highly metaphorical I mean that the main markings have been used sparingly but vividly to show the main changes of direction between planes or indicate a main movement. The indication of the folds of cloth on shirt and pantaloons of Watteau's *Oriental servant* (12) are a fine example of the latter.

I remember as a first year student being taken aside in the life room by the Principal of my school, William Johnstone, who fixing me with a meaningful glance quoted Blake's:

'Tiger, tiger burning bright
In the forest of the night' . . .

and then said 'that's what you want to do Croney' and walked away. It is what we all want to do if we can only pull it off.

The four studies by Michelangelo of a crucified man (26a) is a fine example of a figure drawing in which the main markings have been used sparingly but vividly to show main changes of direction between planes and at the same time tell the main story behind the figure movement. The thematic material here is the tension in the muscles and body parts of the crucified person. The visual metaphor arises in the dramatic marking of the main changes of direction within the body forms. Michelangelo's marking (26b) has given precedence to three positions or 'sets' across the body forms and through which selection the tensions and figure movement are summarised. If we look at the bent knee in the bottom right hand corner, we can see how one of the final marking places in the 'sets' has evolved. Michelangelo has studied the thigh and then the position of the knee between the thigh and the lower leg and foot, his final marking coming on the inside edge of the knee cap to express the tension in the flexed knee. The nuance in the marking is quite deliberate and full of feeling for the bent leg. Another final marking can be found across the lower edge of the ribcage forming the chest; it is a nearly horizontal edge framing the upper portion of the abdomen; the crucified man's chest is in inhalation to support the contortions of the arms. The third final marking is round the knee cap of the fully extended right leg, here the tension of the fully extended leg is stressed and relates in feeling to the knotted thigh muscles above. The final markings are developed nuances built up with many short strokes to express where the artist feels the main change of direction comes between planes. The main change of directions are always expressed as a shadow contour against light, for it is because of light that we can see the change of direction between two planes at an angle with one another. If some planes receive light then some also must be in shadow. The edge of the shadow plane against the light is the position a draughtsman invariably chooses to place the most meaningful marks. This device will be looked at again in the following chapter. It would be possible to strip the Michelangelo drawing we have been looking at of many of its marks except for the three final marking 'sets' and the drawing would still 'work'. The three marking 'sets' provide the essential information in

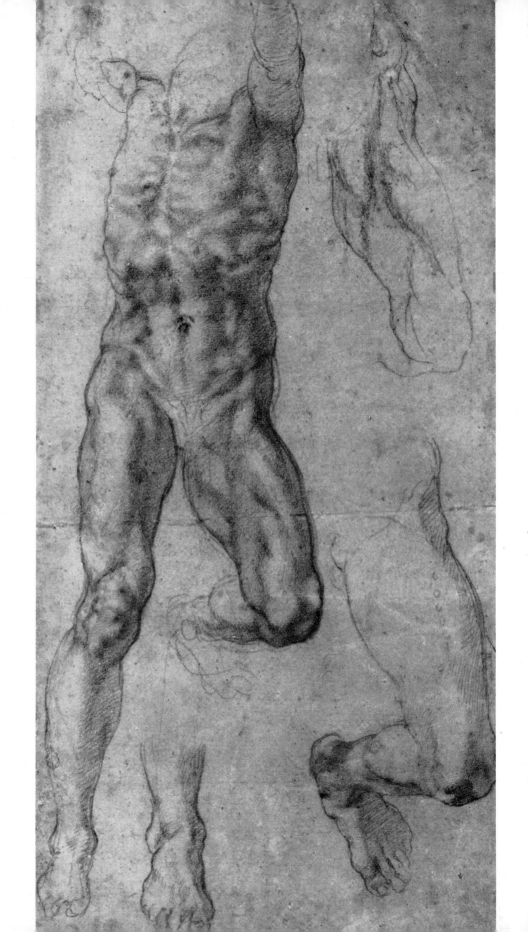

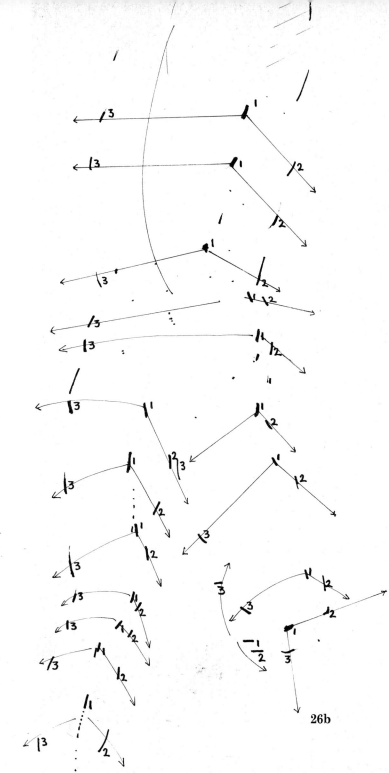

26b

26a Michelangelo (1475–1564) *Crucifixion of Haman* Red chalk (159 × 81 mm) *The British Museum, London*

the drawing and indicate the contortions of this crucified man by the simplest of means. When drawing movement we must always try and give priority in our markings to the full expression of the inside changes of direction using the shadow contour found against the light. There is a sense of hierarchy in this use of the shadow marking, as can be seen in the Michelangelo; he marked down many shadow contours all over the body to express the various muscle tensions, but if you half close your eyes and look at the drawing you can see the precedence he has given to the three positions I have pointed out and why. These three markings are highly abstract, that is to say they are from Michelangelo's mind; on the model it is highly unlikely that the light and shade would have fallen exactly as Michelangelo makes it appear in the studies. The studies show what he took from the model and what he found most important. The drawing process is always like this: a fine balance between how we have seen and what we must do in terms of marks.

The image and the development of drawing skills

To be clear graphically about what is seen we must be clear about what is to be seen and how it can be presented. Thus our seeing must be informed in relation to graphic demands. Young children have not developed the sophisticated form of seeing necessary for the adult artist. The ability to see in a more informed way develops as artistic desires develop. It generally grows through the practical desire of wishing to improve our technique. Within its own terms, the manner in which a child can see of course produces its own wonder. A mature artist will often try to recapture the stance of the child like image maker, perhaps because so often children's visual concepts and expression are appealing, or because the child's vision has a clear and fresh vision of a well-known object. It is in the nature of a child that they cannot sustain a protracted emotional approach to creativity, and they have not the ability to deploy thought and sensibility in the de-

velopment of artistic skills. A person is passing out of childhood when they can use experiment and rational deduction to control and extend the creative process. To a child the total image comes first and is generally presented as a readily assimilated symbol. The image is innocent of extensive analysis of solidity and space, technically it is unsophisticated, its co-ordination and expression based on a simple and unaffected outlook. To develop mature drawing skills it is necessary to think about every facet of technique that is available and practise hard, although at the same time we must preserve our natural artistic sensibilities.

If a child is moved by the whole image to create a likeness as he sees it, a mature artist is moved by the whole image and the command of a sustained technique to create a metaphorical statement about the image which contains some universal visual truth. Drawing is concerned with selected aspects of appearance. The marks a draughtsman uses to do this stimulate his imagination, and are loved for themselves, just as the poet loves words and the musician sounds. When we learn to draw we are learning a new language, and it is a part of a visual language that also includes tone, colour, texture and other materials and forms. Like verbal language, its subject matter is found in everyday life, politics, the home, religion or the world of commerce, and it embraces humour and sadness, developing its own visual metaphors to put its story across to us. Because we are not cameras, the drawings we make are abstractions (that is we make separations or selections by thought and feeling). Drawing language uses proportions and directions. Proportions give distances between marks, and directions made by lines can be drawn in varying angular relationships to the paper edge or format. The Grosz drawing of the *Dancing men* (27) is a delightful example of

27 George Grosz (1893–1959) *Zwei tanzende neger – Dancing Men* Pen and brown ink on paper (125 × 82 mm) *12 Duke Street Gallery, London*

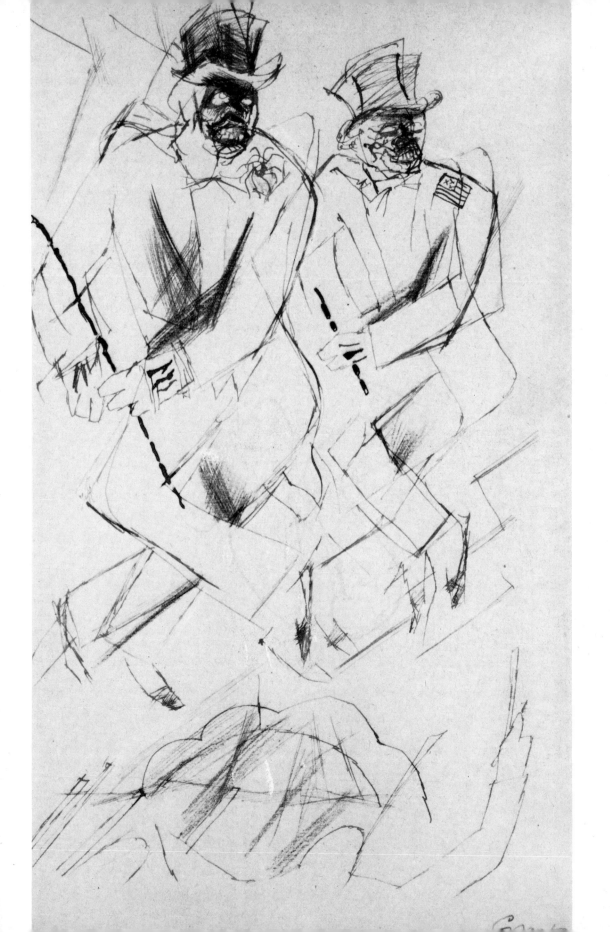

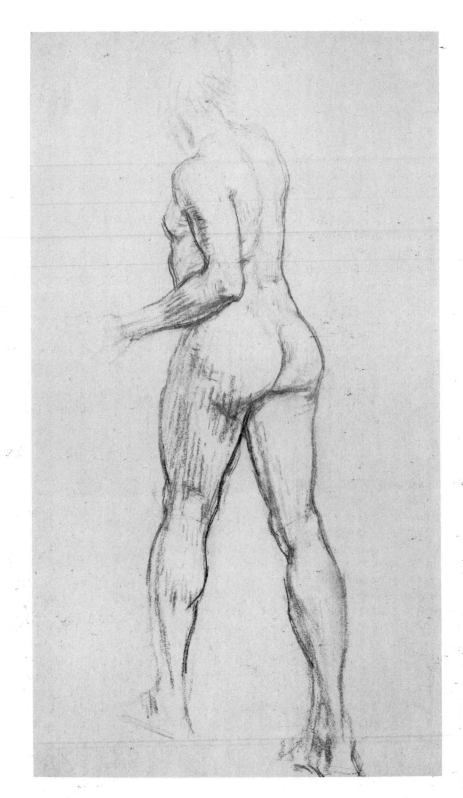

drawing language at work. All the contours of the men are drawn in lines at varying angles to the format with the distance between them adjusted to a series of satisfying proportions. Grosz's work was very much concerned with life, and his distaste for it, and he became a master satirist. As you can see in this example, Grosz has put the abstraction to work to help him make a social comment. But the underlying motivation is the artists love of directional and proportional marking and feeling for movement.

A problem with drawing arises when we have to consider depth and regard the format as being hollow and illuminated with light. Then directions and proportions must function in space. Rosenberg's in his *Back view of a nude* (28) has gained depth by feeling form and space. Look at the space between the legs and feet. Notice how the inside contour modelling down the left hand side of the figures gives depth to all the forms and the direction in which the man appears to be striding. Although the surface of the format records the draughtsman's activities he is equally concerned with what lies behind it.

Using the format

The marks made in drawing are often related to the edges of the paper, the format. The world to which we are accustomed is constructed on the basis of vertical or constructions that rise in line with gravitational force (29). The perpendicular sides of the format ape these verticals and can be a permanent reminder of this force. It is not a bad idea to inscribe a number of verticals on our paper surface before we commence drawing. They will remind us that as in building, when we are making a representation of three dimensions we need to be aware of a line depicting the force of gravity. A plumb line that will either pass through the base of our forms or be a line about which all the dynamic direc-

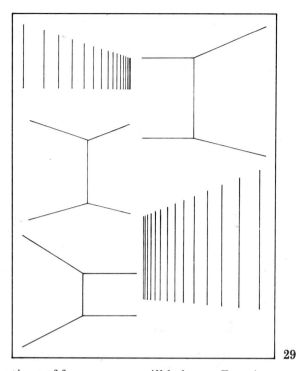

29

tions of forms we use will balance. Examine both the Toulouse Lautrec drawing of the dancer (20) and the Tiepolo drawing of a man in a cloak (21) and sense the line of gravity about which their figure forms balance.

Depth and space

Diminishing verticals create depth, edges of rectangles joining them at less or more than 90% create depth by linear perspective. The format becomes a frame through which we look into the imagined space beyond the paper surface or picture plane (29). In this diagram I have used verticals and associated depth lines to give impressions of space in the paper. Although drawing a corner is a simple thing it is a very necessary piece of preliminary practice if one is to have the ability of drawing movement in depth. For the beginner, the space imagined behind the picture surface must be general and extensive, although the individual development of a more personal style later may dictate more of a surface two-dimensional representation. Study Giordano's drawing of *Jupiter riding an eagle* (2) and see how its execution is rich in

28 Isaac Rosenberg (1890–1981) *Study of a nude woman, walking, seen from behind* Black chalk (481 × 276 mm) *The British Museum, London*

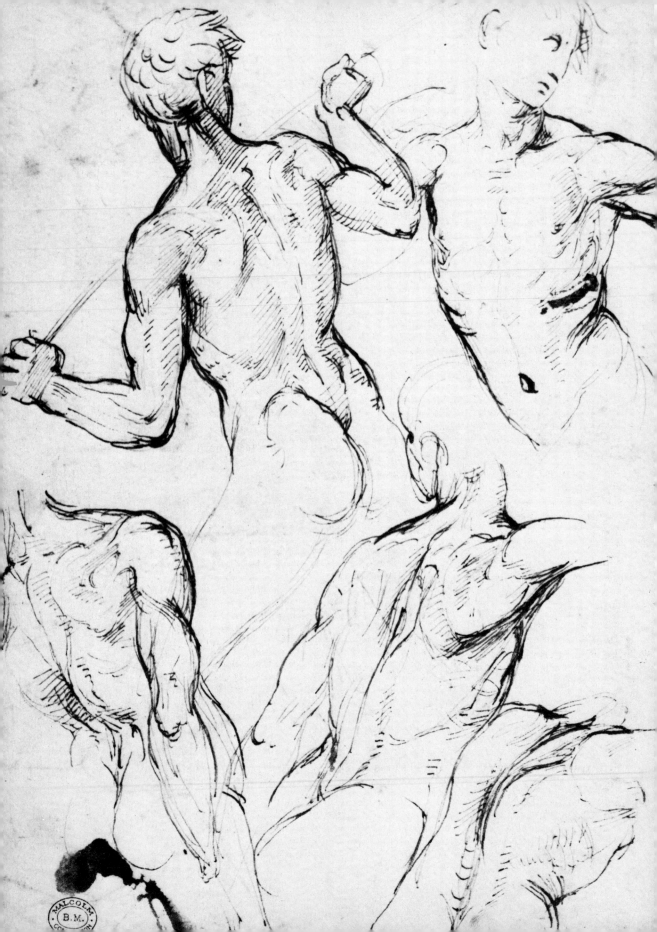

surface arabesque-like movements although at the same time functioning as form in space. The imagined space inside the paper surface may be compressed in this way and often is by draughtsmen who have reached a maturity with their technique. Extensive space is perhaps weakening to design and the compression of it can enhance the image or the tension in the drawing. Good drawing both opens up space and compresses it.

Selection and simplification

In our everyday lives we see by means of symbols. When we are running to catch a bus we are aware that it is green, yellow or red and is of a bus like form with the number labelled on it we require. In everyday biological survival terms, we have not time, nor the trained inclination, to do more. When hungry we rapidly recognise well known food shapes and despatch them in convenient time. We do not generally make a comparative study of their form proportions and intimate textures and details. Thus our everyday vision is a survival one of a highly generalised character which co-ordinated with our other senses enables us to deal quite adequately with the rich soup of happenings which constitutes our worldly life. Much of each new day is happily repetitious and our normal responses are managed by conditioned reflexes. Every day will also contain some phenomena which is new to us, which we must deal with at a conscious level and which may involve us in learning. The artist draughtsman faculties are similar, but when starting a drawing it is always assumed that the day's subject presents new phenomena, the assumption is that the subject has never been seen before quite in the manner,

position or light, that it is being seen now. It therefore has to be examined carefully and more searchingly so that the true novelty of it is discovered. An analytical method of seeing becomes a necessity. This approach is quite different from that of a child, the stereotype is avoided and the aim is to discover new and more exciting forms. Each fresh day's work discovers new relationships or new visual values.

Reinforcing the drawing

As each fresh subject is a fresh problem, we must have some idea about how we shall make a start, what kind of marks it is best to use, where they should be placed on the paper, and how best we may go about reinforcing them.

The method of reinforcement is particularly important. A drawing that starts well may be ruined by follow up work that is contrary in spirit to the initial style of selection and simplification. My starting marks vary from being quite light to quite dark, but for a beginner I counsel them to be light for this allows for alteration without rubbing out (a useless time consuming business particularly when one is attempting to make quick drawings of figure movement). Light marks also allow a privacy which I think is important when a first selection is being made that will undoubtedly require adjustment.

When making drawings of figures in movement the idea of reinforcement of marks in a technique is vital. Look at the Raphael *Torso studies* (30) or the Grosz sketches of the *Dancing men* (27). In the Raphael studies it can be seen that the selection of marks that was used to reinforce the figure forms also reinforced the spirit of the movement suggested. In the top left hand study pen lines pass across the man's back modelling his anatomy; at the same time they suggest his movement into the space to his left. In the bottom right hand torso with a head, all the reinforcing pen strokes from the waist and up through the shoulder blade suggest a lurching forward movement with the right arm

30 Raphael (1483–1520) *Five nude men*
Pen and brown ink, with traces of
underdrawing in lead point (270 × 197 mm)
The British Museum, London

leading the movement. Study this sheet and learn how the reinforcing marks aid the kinetic effects that Raphael was after. It is a lovely fresh sheet of figure movement sketches.

In the Grosz sketches the reinforcement marks are equally instructive. Look at the left hand man and see how the rather agitated movements that are suggested for both his arms and legs, their criss-crossing in an American style tap-dance of the 1920s, is reinforced by the cross-hatching technique on the front of the man's chest and his left thigh. Discover the cross-hatching technique on the other figure and in the suggested foreground shapes and it will be realised that the whole of Grosz's sketch sheet suggests an animated diagonal trellis work that concertinas as you look at it. A quite inspired piece of movement drawing. It is also a fine drawing because it exhibits great powers of selection and simplification.

Reinforcement marking arises from the artists' feelings about what the subject is doing, and they are made to give full expression to these feelings. Technique may change to express form movement and the depth of the draughtsman's emotions aroused by them.

Selection and the use of the gestalt

The process of selection is done in instants, instant looking, or instant feeling and followed by instant drawing down of marks. There is no other way. What makes drawings different from one another is how these instants are used; each of us has to use a form of mental filter that allows some impressions to pass and which blocks others. As we shall see in a moment, by the very nature of our perceptual mechanism we already possess a ready made filter system, so it is not something that we must painfully acquire but rather a mechanism which we should understand so that we can extend its use to our advantage when drawing.

I discussed in the previous chapter the need for a pattern system of approach when drawing; moreover a pattern that can be constructed with priorities in mind. The filter of our perceptual mechanism encourages and aids us in this form of approach. In helping students with the pattern approach I have found the work of the Gestalt psychologists in the field of certain aspects of perception to be remarkably helpful. A useful translation of the term Gestalt could be a whole pattern or form. The Gestalt school has determined that within our perceptual system there is a grouping principle at work which has a capacity to organise visual phenomena into a greater whole. For example if we put down three marks at random that are reasonably close together we see a triangle (31). If we place the marks at random up and down we see a wavy line or a curved line element (bottom 31)

The Gestalt psychologists' description of this phenomenum as: 'the perceptual whole is more than the sum of its parts', also happens to be a very good description of any drawing that works. Look at the Daumier drawing of the *Two barristers* (8) again. There is no doubt we see two barristers walking towards us; the drawing works. But when we look at the means that have been used to convey the figures and the robes they are quite slight. As we look at the drawing in more detail, we can see that all the marks in it are full of suggestibility because they are put down so that they may link up and make a perceptual whole. Look at the lower half of the gown on the barrister on the right hand side: a series of masterly pen strokes moving down from the abdomen and tapering a little to the ankles depicts its full weight and movement on this corpulent figure. We believe the marks to be a legal gown. Examine the marks which make his hat and try and discover how we are 'kidded' into this belief. Once you get the knack of linking draughtsman marks together, you can go through their process of seeing and feeling and learn about the skill and fun of drawing at the same time. Look at any of the drawings in this book, for this point of view, and see how in every case the sum of the drawing – that is what it conveys – is greater than its parts. Michelangelo's

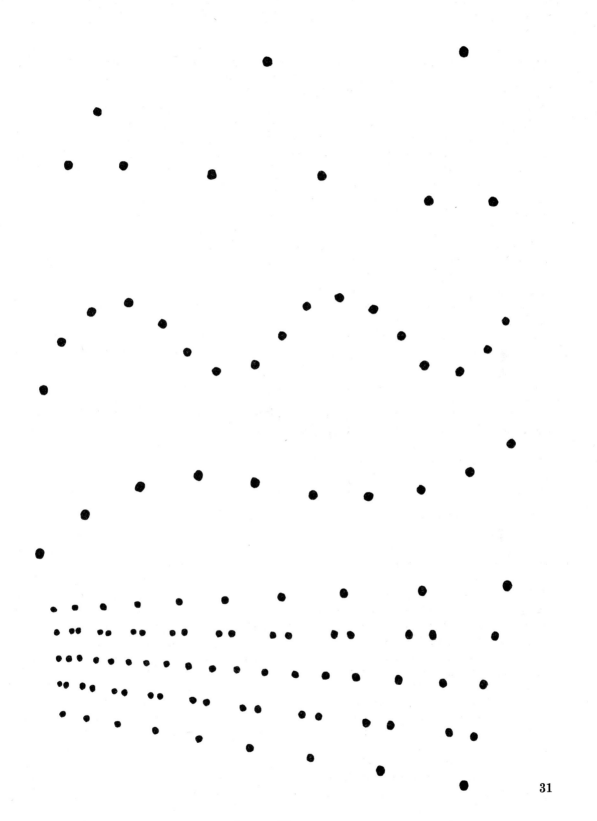

31

drawings offer a rich ground for learning about this aspect of drawing.

So it looks as if the 'grouping principle' phenomena of the Gestalt psychologists has been known for a long time. Yes, I believe this to be true. It is part of the nature of our perceptual mechanism and I am sure that artists have made an intuitive use of it for many centuries. It is such a useful piece of knowledge to have, that I believe it is worth giving some of our thinking time to and also time for practical experiment with its use. Place down marks of different kinds in as many arrangements as possible and see what you can suggest.

The 'pictures' you can see suggested in the coals of a fire or the texture of a pavement, a lion's head may be, you see because of this 'grouping' principle. I shall be looking again at how we may use this grouping principle to filter or select from a subject in the next chapter.

The Gestalt and the imagination

I think we can see now how we might use marks to build up forms and images, and also that to enjoy a drawing, and learn from it, we must be able to scan and re-scan its marks. To feel movement in a drawing we must feel what its marks are portraying.

If you should say but what about the subject or the story in the drawing? The answer is you read this through the marks. Your imagination will deduce it. The subject of course is important but no more important than the marks which make it. A master's drawing is one where a few eloquent marks convey the whole subject, the marks form such a strong visual metaphor that one's imagination is jogged into use to determine the whole image. Van Dyck's sketch of *Christ being supported by men* (32) is just such a drawing.

This drawing has been made swiftly with great economy of means but as you scan it you realise your imagination has been called upon to supply a great deal of the subject. Look also at the *Study of a nun* by Degas (3) and again at the drawing by Tiepolo (21). A

good drawing is like a good piece of music; it suggests so much more to our emotions than upon examination you would think its technique could allow. I believe the Gestalt 'grouping principle' provides one of the bases to reach this sort of standard with our drawing.

Pentimento, energy and movement

As you have looked at the drawings in this book, you may have thought about the energy they express. Look at the last one again, *Study of a nun* by Degas (3). The downward sweeping strokes seem charged with energy. If you are to draw movement successfully, somehow your marks must be charged with energy. The energy that you see expressed in the drawings in this book is I think bound up with their eloquence and the *rightness* of their marks. They each also portray a confident style. The confidence must stem partly from the fact that most of the artists shown had done quite a lot of drawing before they produced the examples you are seeing. When drawing, sooner or later a mark is put in the wrong place and an adjustment has to be made with another mark alongside. Certainly in the initial stages of building up a drawing the so-called wrong mark is left, not erased. This means that the artist's change of mind is left to be seen. This is called pentimento (from the Italian meaning repentance). Part of the successful art of drawing is to use pentimento. Pentimento marks are not dead and useless but they add animation to the grouping of marks. Indeed, they often add alternative paths to the scanning process and make a drawing more alive and animated. When mistakes begin to be left and one learns to build up a drawing by repentances, then confidence is being shown in the drawing process. Rightness of marking comes through putting down a bolder pentimento to correct a previous mark.

Pentimento of course may finally incorporate, or cover over, the previous marks. In this student's drawing (33) a lot of adjustment has been made and left. The contours

32 Sir Antony van Dyck (1599–1641)
Christ crowned with thorns Pen, brush,
brown ink and wash (260 × 285 mm)
The British Museum, London

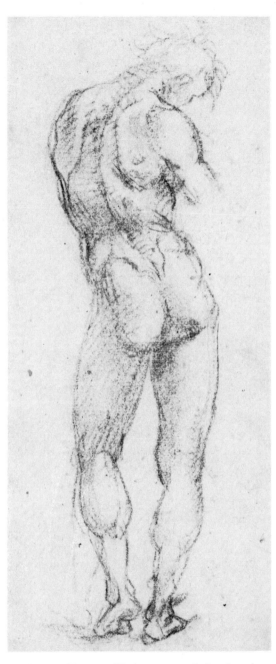

have become very bold by leaving the mistakes. In fact, it is difficult to realise which are the marks that the student thought were mistakes. This is very good and means that all the marks were finally seen as a whole. The drawing has gained a lot of life and power from the pentimenti. The realisation that one can draw without rubbing out gives this sort of confidence. Look at the following artists drawings and see if you can discover where they have made repentances and left their mistakes: Michelangelo's *Flying angel* (5); Daumier's *Two barristers* (8); Blake's *Angel* (13); Lippi's *Nude man* (19); Grosz *Dancing men* (27); and Signorelli's *Nude man* (34). If you cannot see repentances in some of the other drawings in the book, it doesn't mean they were not made, but rather that the completed drawing has obliterated the mistakes. Pentimento can indicate that the pose of a figure changed, and the artists went after the changed pose. The use of this sort of pentimento can actually have a kinetic effect, the figure appearing to move; this is often used to good effect in graphic work. A purposeful shift of gestalt markings are set up so that one obtains a second image slightly offset from the first, a third image can then be offset again and so on. Villon, Picabìa, Lhote and notably Duchamp at the beginning of this century were very interested in creating images in this way. As the marks are juxtaposed the pentimenti add more and more to the power and movement of the forms. The continued pursuit of pentimento requires an artist to have extreme concentration and much energy. Energy is needed not only for marking and re-marking, but for maintaining ones empathy for the image and feeling for the form. As well, the use of pentimento encourages ones energies because one can see the drawing 'coming right', and the expression you desire emerging.

34 Luca Signorelli (1445–1523) *Study of a nude man* Black chalk (270 × 136 mm) *The British Museum, London*

33 Caroline Hazelwood 597 × 419 mm

3 creating form and movement

Using a pencil to check directions

One of the first things to learn when starting to draw is how to use the pencil as a checking device or measuring stick. Later, after practice, it may not be found necessary to measure quite so much; personal style will finally determine the significance of measuring for each individual. It is not too much to say however that it will always have a role in your drawing and it certainly needs to be known so that it can be called upon when necessary. So some time should be spent in the beginning learning how to measure with a pencil.

For checking movement and for feeling the movement a pencil is used to give a plumb line (35A). Plumbness obtained by gravitational force will establish a perpendicular against which many other angular directions to it can be judged. The pencil is held by the point between finger and thumb so that it hangs straight down; it is then moved into a meaningful relationship with the direction to be judged. The plumbline and the direction will enclose an angle between them, which must be guessed and then represented in the drawing. Estimating the degrees of the angle need not be all that precise to a degree. A good hunch about it is enough, telling yourself the angle is nearer 15° than 30° for example. When drawing with a short crayon or some form of stub it may be necessary to make a plumb line with a piece of fine cord and a small weight.

The plumb line idea can be used for establishing the whole general direction of a figure movement or its individual parts. A beginner should consider using a number of plumb lines spaced across the paper where the figure is being drawn. Also a plumb line will establish whether one point on a subject is vertically above the other. For example whether an eye or ear aperture is vertically above an ankle. By using a plumb line for this purpose the whole balance of a pose of a subject can be understood (36). The plumb line in my drawing drops from the outside edge of the bridge of the nose until it finally coincides with the inside edge of the model's left ankle. But luckily it also coincides with the outside of the left knee and the edge of the neck meeting the shoulder. One often gets luck of this sort. Repeated checks of this type are generally necessary until the attitudes of body parts in a pose are memorised. Once developed, the knack of using the plumb line remains with a draughtsman.

If it is found that a direction being sought is rather nearer the horizontal than the perpendicular, then the pencil should be held at the horizontal (35B). This needs a sharp visual judgment on what is horizontal but it can be done with practise. It may take a few seconds to satisfy oneself that it is indeed horizontal, and it will probably have to be done against a pattern of angular perspective directions round and in the subject. Once confidence is established in holding the pencil like this then the pencil can be moved into a meaningful relationship with the direction to be judged. As with the perpendicular check an angle can then be noted and used in the drawing. It does not matter how much time is used up in the initial stage of

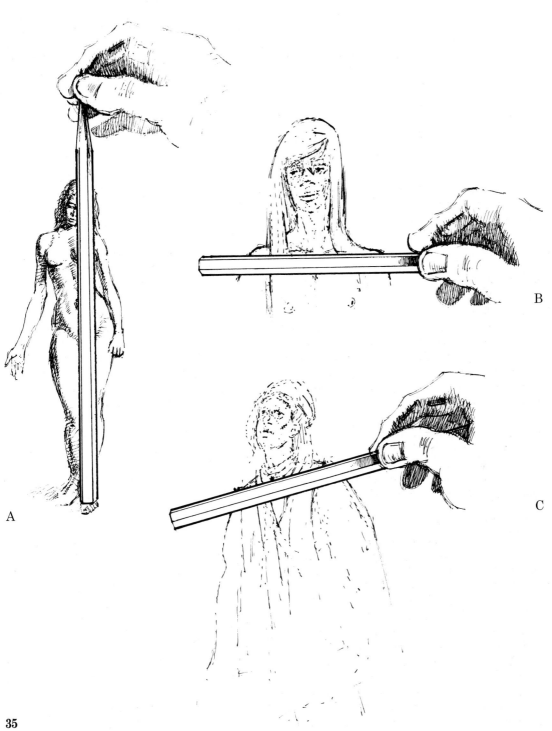

A

B

C

35

learning to draw establishing verticals and horizontals. By repeated use the process will become quicker and at the same time one will have gone some way in learning to see significantly, and learning to judge visual facts by test rather than assuming one can know them at a glance.

Occasionally it is good to practise drawing vertical lines free hand on the paper and draw several down the paper so there is the beginning of a grid that can be used in relation to ones checking as the drawing builds up. It is absolutely necessary when attempting to draw a standing pose with or without much movement to draw one free vertical towards the centre of the paper that is used to correspond with a plumb line through the model from a point in the head to some point at the feet or base.

After drawing for a time another plumb line adjacent to the first may need to be drawn (36). The drawn verticals will assist in the understanding of the balance between figure parts in relation to gravity. When drawing a figure from memory they still may be used because they do provide a strong sense of reality. The reality that in our world any form of construction in sketching or building must relate to gravitational force.

Testing the perpendicular and other directions

When the drawing surface is paper pinned on a board, the perpendicular side of the board can be used as an aid in drawing verticals. First make sure the paper is secured parallel to the board. Then holding a well pointed pencil by its extreme end at right angles to the palm of the hand, the edge of the surface of the palm of the hand under the little finger is then allowed to run down the edge of the board. The pencil point should then draw a line parallel to the edge of the board as the hand moves down. Lines at different distances from the board's edge can be traced by shifting the hold on the pencil. With a long pencil verticals can be established well into the paper.

Any oblique movement seen in a figure can

36 559 × 229 mm

62

be tested by holding a pencil up against it, the pencil mimicking the movement in space (35C). The mimicking pencil abstracts the movement, and for a fraction of time the direction is clear in the mind, and can be rapidly sketched onto the paper. A mimicking pencil angle can also be held and the whole arm dropped so that the pencil angle is seen against the paper as confirmation or criticism of directions building up (37). All the main and most exciting directions you can see in any drawing could be, and should be, tested in this manner. *It is surprising how vertical and horizontal the main directions in a drawing can become if this is not done.*

Measuring

Measuring the proportions or dimensions of a subject is also an important part of drawing technique. It enables one distance to be compared with another, or alternatively used to discover how many times one part of a subject goes into another part. It is often useful to use head height as a unit part and to discover how many times head height goes into total figure height. This is done by holding the pencil with a fully extended arm locked at the elbow. The pencil is then adjusted in the hand until it is perpendicular, non pointed end at the top. The top of the pencil is moved exactly to coincide with the top of the part to be measured, say the top of the head. The thumb of the hand holding the pencil is then moved up the pencil until its top is exactly opposite the bottom of the part to be measured, the chin. With the thumb held firmly clamped on the pencil the top of the pencil is moved down until it takes the position the thumb was at, the chin. It is then noted where the thumb is in relation to the figure, say the bottom of the breast. Still keeping the thumb fixed on the pencil the top is moved again, this time to the bottom of the second part, the bottom of the breast. Again it is noted where the thumb is in relation to the figure. The method is repeated downwards until the whole figure is covered. A count is kept at each part measured, including the first part, until it is established

37 457 × 203 mm

63

how many of these parts or head heights goes into the whole subject. This could be six, six and a half or seven and a half times. Thus a head height unit may be used to establish the general proportions of a figure. In my drawing (38) the figure is six heads high. The head height including hair and a rather full chin. As long as the thumb of the measuring hand is not moved between making comparisons the arm can be rested. Also if the thumb is not moved other proportions can be tested; head height can be turned from the perpendicular into the horizontal and used to establish shoulder breadth. So providing the thumb is not moved after the first part or unit is measured off, and providing also when comparisons are being made the arm is always fully extended, a very wide range of related proportions may be tested either in the perpendicular or horizontal planes, or any more free direction.

Other parts of a subject may be used as checking units in a similar manner. For example, a thigh width checked against waist to pubis; eye level to chin checked against upper arm width and so on. There are two main reasons for such measuring practice. One reason is that different proportionate relationships will be found in different people or different action poses, so the idiosyncratic nature of varying body forms will be discovered. The second reason is a measuring routine goes a long way towards teaching one to see proportions as they actually are. Having once experienced the method ones memory drawings are much improved. Being able to command a method which allows much greater insight into visual truth is very exciting and stimulating. It is very likely that a personal visual discovery of some aspect of a subject will encourage emphasis and nuance in technique. Measuring and discovering new proportions that would otherwise have been missed stimulates the imagination. The visual truth is so often such a delightful shock, however long you have been drawing. 'I've never seen that before'! one might be caught saying, and this is the finest motivator that I have ever met in drawing for it encourages one to go on and explore and do better.

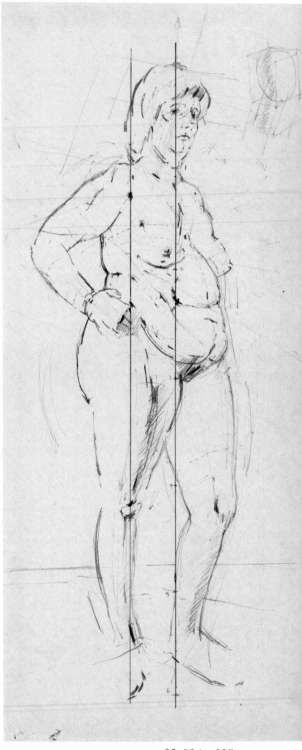

38 584 × 305 mm

The first marks

Once the drawing is started the natural desire is to capture an image, or create an image. A freehand drawing is built up by a number of marks, either established by measuring or freely adjusted, to indicate proportions and directions. Whether this takes a short or rather longer time, the method is much the same. In the beginning the image is indicated in rather a shorthand manner, the first collection of marks being private to the draughtsman, by that I mean they are not meant to be obviously representative of the subject. Drawing particularly in the initial stages, is something that one does very much for oneself. This is a demonstration start I made in front of a student (9). Although you can see the side view of a shoulder, arm and trunk appearing the drawing is clearly at an early stage. You can see the marks I have made are not obviously representative of a woman but rather the beginning of an exploration of how to draw the movement I have seen taking place across her body by establishing inside contours using the edges of shadows. Even the quickest drawing is built up in stages. Each stage will contain some part of the ideas that will be seen in the completed image. To the artist at least each stage is complete in itself however slight it may seem, and would contain some information about the subject; and so our drawing moves through a series of understatements.

Drawing the main changes of direction across forms

Where drawing has to be rapid because of the short nature of a pose, or a fleeting imaginative idea that has come to mind, the first marks or contours are concerned with the most acute change of direction between planes or in forms. As I worked down this sketch I felt the movement across the figure forms very vividly (38). I made many marks to express this, but the marks that were the most vivid for me in terms of movement were the ones that can be seen inside the figure forms. The cheek-bone, the collar bone, top of

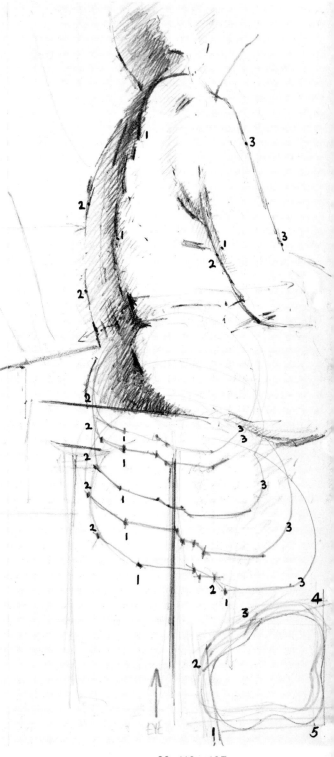

39 419 × 197 mm

armpit, side of chest wall, side of abdomen, centre front thigh and knee cap. These markings give the position of where I saw and felt the main change of direction between planes on the forms that make up the woman's body. Quite protracted studies are still capable of expressing movement across the form when they are complete if the chief aim throughout has been to express the main changes of direction between planes as the most dominant factor. This involves one in making a decision about where this change is. I use two drawings I made for students involving this selective process (39, 40).

A life study of a seated figure side view and a back view of the upper half of a standing figure. In (39) I have determined the most acute change by looking at the model with half closed eyes and then finding out where the edge of the shadow starts on the receding planes of the upper arm and back. This requires measuring from the model with the pencil and concentrated looking to do it. It is however the best way to learn the process. Notice that the shadow edge is not expressed in one hard continuous contour but has been established by a number of marks. This must be so because of course any section through a human figure will not be like a section taken through a cube. There will not be hard edges of exactly 90°. So the acute change I talk about is perhaps something near 90° but rounded off by muscular and fatty tissue. This drawing (40) was done on another occasion but attempted to teach the same things. It is interesting to examine because in one part of the figure it had to be accepted that a number of changes were present one being no more dominant than the next. So they were all equally marked. You can see this happening in the shoulder and armpit area. The model had a great amount of fat on the upper arm and in moving the arm back compressed it into folds down her back. Each bulk needed three markings. The arm itself had three, one of its contours serving also as a contour for the first fold of fat, one of its contours in turn serving as a contour for the next fold. The main bulk of the shoulder section being

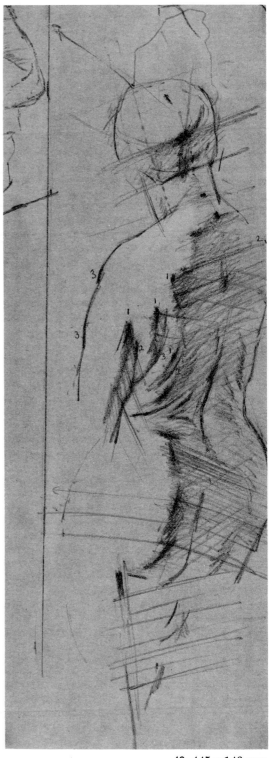

40 445 × 146 mm

66

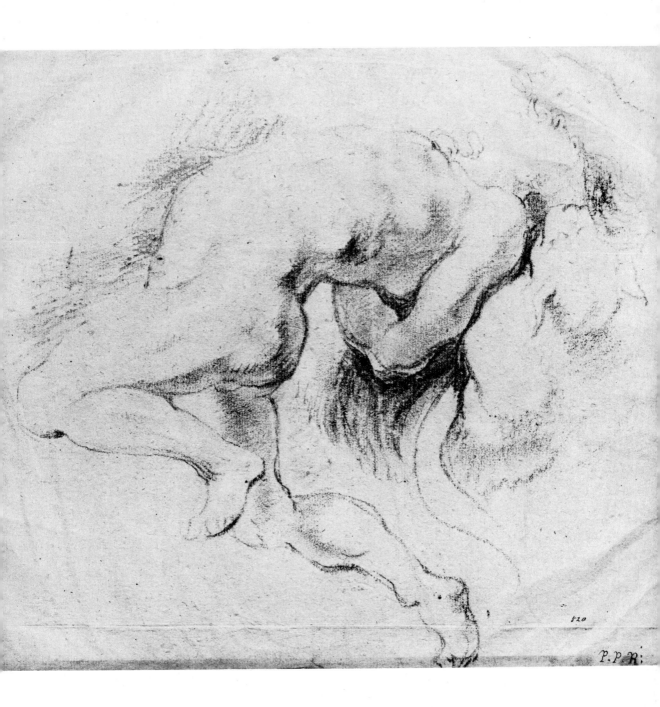

41 Peter Paul Rubens (1573–1640) *Study
for the fall of the damned* Black, white and
yellow chalk (258 × 305 mm)
Victoria and Albert Museum, London

expressed by three markings above. This is quite complicated, calling for clear minded decision marking but it can be conquered in time.

Keeping back from a drawing

It is a natural tendency to start with small parts and distances and analyse these. The necessary overall appraisal of a pose or action takes a little time. It involves the ability to move away from a drawing so that it can be seen as a whole within the format, and also the ability to be able to work on one part of a drawing, such as the upper arm in my drawing, but at the same time be aware of the place this detail has in the whole subject.

In Rubens' study of the tortured man for *The fall of the damned* (41) main changes of plane across the figure forms are clearly marked. The lower chest waist and buttock sections dominate and the torture of being forced over backwards is felt. These markings also form a psychological focus in the sketch and are composed within less accentuated marks nearer the format edge. As long as any marks made in a drawing finally fit into the whole as Rubens' do, it does not matter if smaller distances are used in the beginning. In fact it often happens that the first markings do become the psychological centre of the drawing.

Learning to move back from a drawing as it develops is an important technical device. A colleague I once worked with used to say to students struggling with their drawings: 'If you can touch it you are too near'. Moving back means that the entire drawing is in one's cone of vision, no head movement is required. It also means that one can draw with the whole arm straight from the shoulder. Keeping the arm straight one can rapidly traverse a drawing; a mark here and a mark there, pulling it together the whole time. Moving back also means that when working from a subject the pose or action can be seen easily as a whole. It is a working position that allows viewing both the subject and drawing with the minimum of head movement and is the easiest position from which to draw. Little memory work is required and the subject can be easily scanned and compared with the growing drawing.

Making forms move

To create movement, the first marks should be so placed that they define *one plane or shape in dynamic relationship to another*. Movement has to be imagined and felt from the very beginning. With the paper quite empty and just a few marks appearing this is not easy, for the process demands a permanent break from writing ideas, and recognition in practical drawing terms that your paper, as Seurat said, can be imagined to be hollow.

To create form movement in the abstract in depth we require at least seven points or positions being marked down on our paper. I would suggest you do this a number of times in the different positions you see in my diagram (42). I have made them to show how we can relate seven positions together to indicate the form movements on a cube when it is placed at different angular relationships to our sight. In the three cases a whole cube has been modelled to show how the seven positions have been taken from them. As we see form by means of light and shade, so the use of light and shade as it appears will represent form.

When we look at a cube lit from one side against a plain background, we can observe for ourselves what is meant by the dictum 'there are no lines in nature'. The positions we can use to indicate a cube are taken from where the shadow edge is silhouetted against the light edge, or where a far light edge on the box is silhouetted against the darker background. If we put all the positions together along a shadow edge we have a direction which is one whole edge of a plane of the box or the background, the direction being on the surface of the box or the background. Thus the directions we make as lines or contours in drawing are abstracted from the surfaces of objects and there are therefore no lines in nature, merely the ends of planes. From this

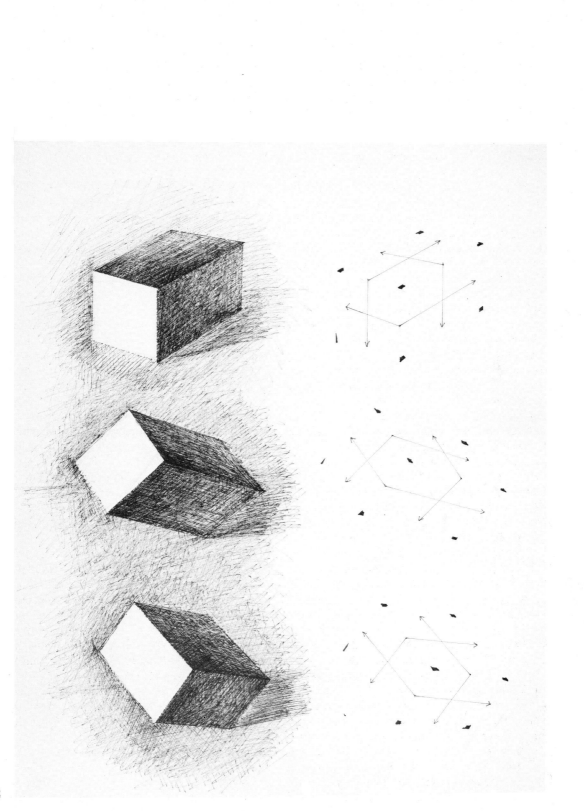

observation and reasoning there arises a very important rule in drawing which states that 'a draughtsman should know from which plane edge his positions have been taken when they are marked down'. There are no lines in nature so there can be no loose marks scattered about, all drawing markings should relate to form. It is a rule that goes a long way in helping one to decide how to draw contours. It doesn't matter so much to an established artist but for someone starting to draw or wishing to improve their drawing, it matters a great deal. Look at the drawing by Rubens again – the study for the *Fall of the damned* (41). Hold a ruler or pencil across the man's waist in a 45° direction. At the top you have the bent back direction of the man's stomach; see how this is marked by the end of the background direction silhouetting the light shape of the stomach; the inside marking of the waist is derived from the silhouette of the lumbar plane against the front of the abdomen; the final mark is from the darkened lumbar plane silhouette against the light background. So three positional markings draw the waist shape, the first one ON the background, the other two are ON the figure. It also should be remembered that only three markings were used to show this piece of form movement.

The diagrams I have made to show how we can relate seven points together finish each of their three sequences with an indication of a cube by means of seven positional markings (42). If the seven marks bear a correct positional relationship to the parts of the planes and background of the cube from which they have been derived you will see a cube form. Try doing this, as boldly as you like, a number of times. Each time you will have to get the seven points in a meaningful relationship. If you succeed they will mean cube. You have demonstrated to yourself that if marks are put into a meaningful visual relationship you can use marks of any type. It is their visual relationship that is crucial, not the way they are made. This is what Velasquez meant when he said 'Give me a dirty boot and I will draw anything you like', and

why Hokusai was anxious for his students to see him draw with anything that would make a mark. (See the beginning of chapter 2).

The Gestalt and form movement

You may have realised that in manoeuvring your marks to make a meaningful visual relationship you were making a Gestalt. That is, you were grouping points in to 'sets' that were found by your perception to have a *common property*. You can rely on your visual recognition system being able to comprehend *clusters of features* in a subject in this manner. In fact analytical or selective drawing depends on being able to make feature description from form structure by means of perceptual groupings. In the case of the cube, its description is perfectly conveyed by a grouping of seven positions in a 'set'. What you construct any other observer will be able to read back and obtain the correct message. Here we have of course returned to what I was saying we wanted in chapter 2. In summary I said because we are not cameras but work with a series of 'instants' we need to be able to start with a pattern that both we and our observers can understand. The pattern or feature description must remain intelligible as we continue to build it up, and when it is complete.

It would be a good idea if you now carried out a whole series of experiments with this method and drew as many cubes, rectangles and reasonably simple solids as you can. Rather as I have shown in my drawing of different solids drawn with positional markings in 'sets' (43).

If you draw forms other than the cube you will find that the number of positional markings will need to vary. If you consider what you have to think about when you are making these grouping experiments, you will realise it comes down to two things: distance or proportion and angle. I am told that when Sir Henry Tonks was teaching life drawing at the Slade School he used to say 'Anyone can draw who can judge a proportion and angle'. A Gestalt grouping of a seven position 'set' to indicate a cube (44) needs your continuous

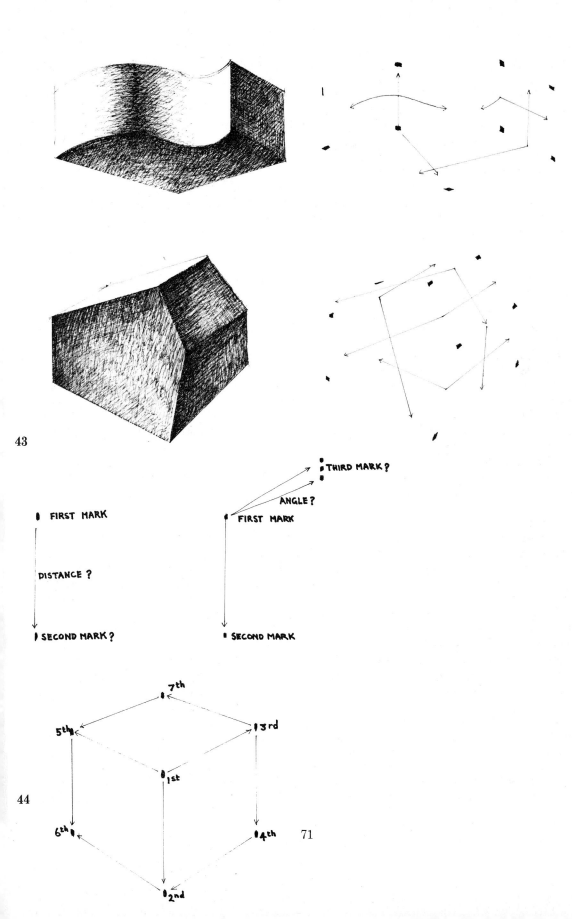

43

FIRST MARK

DISTANCE ?

SECOND MARK ?

THIRD MARK ?

ANGLE ?

FIRST MARK

SECOND MARK

7th

5th

3rd

1st

44

6th

4th

71

2nd

45

judgment of these two things if you are going to get the feature description of it correct. When marking out a cube using your second positional mark, added after the first, you will have considered distance (or how large the cube is going to be). With your third positional marking you will be forced to consider angle, because the third mark indicates a direction moving away from the direction indicated by the first two marks. You will then consider how far the third mark should be from the other two and so will be considering proportion again. To place the fourth mark you will need to consider the angle of the direction it indicates. This process repeats itself until the seven positions are indicated. Have you got pentimenti? I expect you have, but leave it in, and just make the correct marks bolder or in another colour. Look at the Rubens drawing again and study the markings of the shadow nuance for the waist (41). Somewhere in it there is pentimenti for this is a built up and adjusted marking as Rubens felt for the Gestalt 'set' to indicate the waist form, and which he judged were sufficient elements to draw this feature.

A Gestalt 'set' will not be functional unless we get the distances and angles between its elements right. For those intent on really improving their drawing I would sug-

gest that they make numerous sketch book studies by 'sets' from still-life groups, corners of the home, natural forms like tree trunks and rocks, as well as from the human model.

We have now moved away considerably from writing. We believe our paper is hollow because we believe our Gestalt of the cube is solid. The cube goes into the paper! When drawing the Gestalt 'set' of the cube, we have also created movement, because some of our positional markings have indicated a plane in a dynamic relationship to another plane (42, 43). If we make the angles between the planes more acute we obtain a more dynamic visual relationship – we feel the change of direction between the two planes more vividly (45). This is basically for two reasons. The first is because we have succeeded in showing two planes which when we apprehend them through our projected feeling of touch, our tactile awareness, do not continue smoothly one into another but give us an abrupt change sensation. The second is related to our sensations of rest and movement we derive from viewing directions. Horizontal directions parallel to the top and bottom of the format are tranquil, vertical directions parallel to the sides of our format are firm and relate to gravitational force and the natural aspect of reality. Both horizontal and vertical directions are static although

vertical lines may be very vitalistic. Any diagonal however is felt to be dynamic, it is contrary to the 'static' nature of the format frame and introduces an expressive element into the use of directions. Diagonals can be arranged in an infinite number of relationships and are used to provide angular movements in drawing. They must therefore be considered the chief element in drawing figure movement.

In the preceding discussion I have assumed that when we used positional markings to make a Gestalt 'set' we could 'see' and 'feel' the directions between them as contours. I hope you will draw enough trials to make sure you can do this. I have made some sketches to indicate what I mean (46). They only need to be indicative, and try and feel them as contours at the ends of planes and as directions in the paper space. So they should be done with imagination and feeling, for they are, together with the Gestalt positions, spatial elements which afford a range of tensions as vital forces.

It has been suggested already that studies from the life figure should be made, a number of which need to be of quite a searching nature. This is so that one can practise seeing and selecting dynamic relationships of planes from the figure and expressing them by Gestalt markings.

If you consider the life drawing studies that I made as demonstrations before students you will see that in each case I was attempting to convey my positional markings and the change between plane directions that were the constituent parts of the whole figure forms (9, 39, 40). A good way to see how I arrived at the drawing (40) is perhaps to look at the first one (9). My starting pattern in that drawing is made primarily by three positional Gestalt markings, the back edge of the figure, the edge of the shadow on the arm and some markings for the front of the figure. You can see that the main emphasis was on the second, or inside, marking, the shadow against the light on the arm. I have made this second marking the main one because I felt it showed me where

46

the most important change of direction came from my side view of the model. It was also the nearest part of the model to me, and finally it also allowed me to express my feelings of the movement across the form. Of course the model was stationary. Nevertheless for reasons I have previously explained in making forms move I felt movement. Returning to drawing (39) you can see that I did much the same thing here. I need the light and shade on the model to help me discover Gestalt 'sets' and with them I expressed my feeling for the form by expressing dynamic changes of plane direction. The shapes you see at the bottom of this drawing were my analysis of imaginary transverse sections of the model's body. To discover where the main changes of plane direction are across a form one has to ask oneself what the geometric shapes of the transverse planes would be if one's subject was cut up in transverse sections. Seeing the light and shade on the forms through half closed eyes is a good way to start doing this. It is the light and shade on

forms that tells us about their solid geometric structure. The numbers show where I think the main changes of direction should be expressed by markings or contours. I have put some numbers on the figure so you can see the application of the method. In this case the first marks would incorporate the arm as you see in my drawing (9), but the arm would eventually need to be built up by its own positional markings. I have numbered them in the lowest transverse section beneath the figure. Drawing (39) shows more extensive and further expressions of movement across the form felt by selected sections. The form is felt, and movement is felt by the markings.

So it would appear that if you can construct form in space by positional markings, you can construct movement in space, and that form and movement are the same things. When I made drawing (38) I believe that is what I was trying to say with it to the student. In this drawing movement has not only been felt across the figure by selective marking, but in many other directions as well. See how the positional markings down the inside of the chest carry on down diagonally and link with the inside edge of the abdomen. The inside shadow edge of the near leg has also been felt together as a movement from groin to ankle. A very useful marking to give the feeling of form in this pose can also be realised if you start from the centre marking at the hair line on the forehead and connect this with the marking on the centre front of the base of the neck, and then trace the centre markings down the front of the chest and abdomen into the pubis. These markings give the movement of the head, form and the angular manner in which it moves in space contrary to the trunk form. More subtle and more beautiful examples of the expression of form movement in space can be found in a great number of the drawings in this book. Look at the Signorelli (34), Maillol (18), Michelangelo (26) and Raphael (11) and continue to widen your studies by looking at many of the others from time to time as your knowledge of drawing language deepens.

You will find that you can feel form and movement in this manner if you apply yourself to steady drawing practise. If it is not possible to use a model, fairly large photographs in strong light and shade will provide useful subject matter. However if you do this you must be sure you work by selecting Gestalt groupings or positional markings, otherwise you are lost. The shadows you see on old masters drawings are not shaded in; they have arrived by selective 'stressed' positional marking; the same applies to any good contemporary drawing.

In any drawing study, searching or quick distances and angles are marked down and the marks are multiplied until they begin to assume some significance to the author. With the quick study the marks are not multiplied so much. Even when working from a photograph you must be sure to feel the form. If the shadow builds up in a searching drawing it does not matter because it contains your search for significance. Walter Sickerts called the multiplication of marks in shadow contours 'upholstery'. Thereby implying that it was not bad. In fact you will still go to heaven if you do it, but also implying that there could be more inspired drawings in which simpler positional markings come more quickly to assume significance. We all need to do both sorts of drawing, *upholstered* ones and simple ones. I don't personally believe its possible to do the second until you have done the first. Some of the best pieces of upholstery in this book can be seen in the drawings of Michelangelo. If you make a study of the development of an artist's skill in drawing you will see many of their drawings, particularly the earlier ones, are upholstered and then with increasing experience their drawings become simpler. The simple contour studies of Matisse would not have been possible without the more searching studies of his youth.

Form drawing and perspective
I hope the word perspective is not too daunting. Do not be frightened off by its use. As our figure subjects are objects in space and their

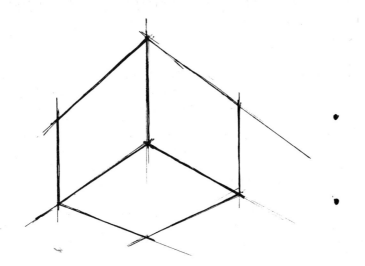

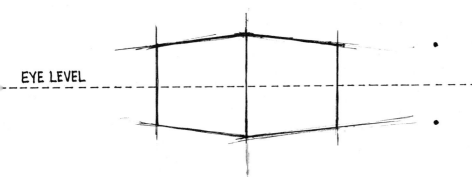

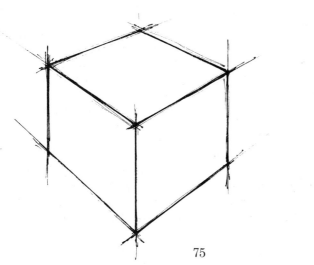

47

various parts at different angles and distances, we need to have some method by which we can analyse their appearance and then represent it on a format surface. Perspective is the art or science of doing this. After drawing experience it is possible to match a visually memorised image to a presently occurring image, but when sketching figures in action it is most unlikely that all their form movements will have been seen before. To build up our experience we must learn to see in perspective; by doing this we shall learn a method of analysing the appearance of objects and then be able to use a drawing method that represents what we see. We have already considered the drawing method, at its most fundamental, when considering the application of the Gestalt method to feeling form movement by selected mark groupings. So we possess the method. Those who have done the sketch book studies by Gestalt from still life groups, home corners etc., will realise that they have been seeing in perspective. That is the objects they have been drawing were either above their eye-level, that is they had to look up at them; or on their eye-level, that is they were looking straight at them; or below their eye-level, that is they looked down at them (47). One object can be held in these three positions in front of our eyes and we shall see a change in its appearance. It would be useful at this stage to obtain a small box or cube, say about 8 or 9 cm, and hold it above, on and below your eye-level. The box form should have the three appearances I have represented. You can see the bottom of the box when it is held above the eye level, and the top of the box when it is moved below the eye-level. I have represented the centre box as having its base on my eye level, although it could have been represented with its top at my eye level. The marks on the right give the Gestalt groupings which would represent these changes of appearance in the box. If I join the three boxes together and make them into one continuous standing form, I have represented the appearance of a simple solid, that is standing on the ground but which extends above our eye

level (48). This object is both above, on and below our eye level. The centre horizontal line is sketched to give an imaginery on eye level line. Again marks on the right give the Gestalt grouping 'sets' which would represent the change of appearance between the different sections of the object as we looked it up and down. The appearance of the sections change because one is being seen in above eye level perspective, one in at eye-level perspective and one in below eye-level perspective.

To be able to draw figure movement or figures in action we need to be familiar with these three perspective cases and the change to be made in the Gestalt grouping that will allow them to be represented. To be able to see analytically and apply the Gestalt method of mark grouping, means basically to be able to see whether an object is in above, on or below eye level perspective.

When describing the use of the Gestalt to obtain form movement I discussed static and dynamic directions. Horizontal directions are felt to be static and tranquil whereas diagonal directions are felt to be dynamic and are used to provide angular movements which can be very expressive. You can now see that the above and below eye-level appearance of objects provides angular movements which are dynamic, whereas the eye level itself provides a tranquil direction. Examine Michelangelo's *Study for the figure of Haman* (26a) and try and confirm your understanding of the use of marks to show above, on and below eye level groupings. If possible make a transcription drawing of your own from it (26b), working from Gestalt mark groupings and only after this building up the shadows to gain more anatomical detail. Be sure when placing the Gestalt marks that you judge the angles and proportions accurately because they will be crucial to the expression of the form movement. In this study Michelangelo has felt the above eye level relationship of markings round the upper part of the chest. To establish the above eye-level marking here look at the top of the armpit, the marking here between the

inside using the pectoral muscle and the outside where the arm leaves the back makes an angle of 45° with the top of the paper. Lay a pencil across the top of the armpit and make sure you realise how dynamic this movement is. Now find the third marking in the contour drawing of the chest wall to the left. It is where there is a small change of direction as the bones of the ribs are hidden by the other pectoral muscle. This makes only a small angle with the top of the paper if you relate it across directionally to the inside armpit marking. Nevertheless because the first two markings are so dynamic the whole upper chest section is expressed in a strong above eye-level relationship and the chest plane moves away from us. If you follow the shadow contour on the chest down you can repeat the analysis of above eye-level marking sequence several times. When you arrive at the abdomen, the dynamic movement across the form ceases and the marking of abdominal and lower chest muscles with their contours is almost horizontal. Somewhere about here Michelangelo must have felt was his eye-level. If you move down the leg on the left until you reach the lower half of the knee, you will find the analysis here takes the form of a below eye-level section marking. The lower positions on the inside shadow markings of the knee cap should be related to higher outside contour markings. You are looking slightly down at the knee. If you cannot convince yourself enough to transcribe the passage in this way, look at the direction lines Michelangelo has used below the knee to express the calf muscles in shadow. They rise at 45° to the bottom of the paper, and if you follow them up the suggestion of the rising direction is maintained right through the knee shadow into the leg above. Michelangelo's struggles here show how the use of sectional markings can be highly idiosyncratic divided in purpose as they often are between representing perspective and feeling. The other knee in a separate study in the right hand corner is in a below eye-level section. The strong marking on the inside of the knee cap both terminates

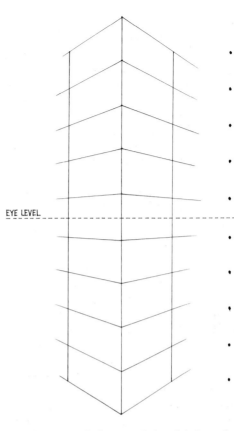

EYE LEVEL

48

the downward thrust of the thigh and starts the form of the lower leg to move convincingly in space away from us in foreshortened perspective.

Spatially this figure by Michelangelo has been conceived as being somewhere above the ground, the ground place indeterminately positioned below the lower format edge. The artist's viewpoint is opposite the figure. The drawing is a study for the *Crucifixion of Haman* (26a) which is in a side spandrel adjacent to the representation of the Last Judgment in the Sistine Chapel, Rome.

Spatial conception is intimately bound up with ones reckoning of above and below eye-level perspective during the act of drawing and we shall return to this topic later on in the chapter.

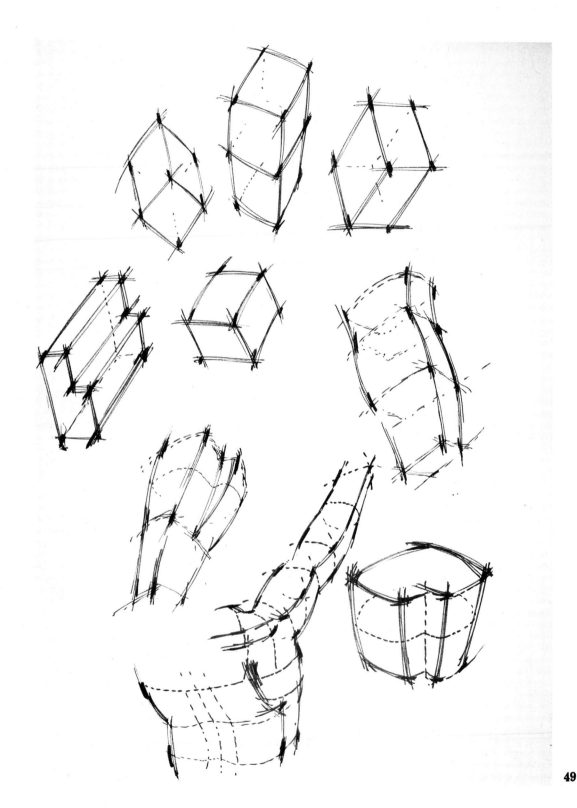

49

Form movement and perspective sections

But first a little more on perspective sections. It will have been noted that my diagram (48) of a continuous box form showing above, on and below eye-level sections is not a perfect visual analogy of the Michelangelo Haman study. The Haman figure study is made up of many forms all of which move at different angular relationships to the format, my diagram presents one perpendicular form. The idea of sectional analysis it presents is far more simplistic than that seen in the Michelangelo. The diagram does however represent the basic analytical process that must be applied when drawing form movement. If we examine the Michelangelo drawing again we can see that in drawing the thigh of the left hand leg an above eye-level section marking has been used. Yet as I said previously, the eye-level is about the abdomen. So in the drawing of the left thigh we have the case of an above eye-level section being used below the eye-level. This is quite correct because the thigh is represented as coming towards us instead of being perpendicular. The thigh is foreshortened in fact, although because thighs are physically larger nearer the trunk than the knee, this may not be immediately realised. If we look at the Signorelli *Study of a nude man* (34) we can see that the sectional marking for the upper trunk is in below eye-level section although above the artist's eye level. This is not wrong and not unexpected. Signorelli revelled in being able to articulate one part of a figure against another with as much plastic force as possible. What we have now discovered is that sectional marking of forms must be related to their orientation or direction in space.

Eye-levels and form movement

In general perspective is a means of unifying an image and so when we are sketching a figure we must know whether it is mostly above us, and governed by above eye-level marking 'sets'; or mostly below us and governed by below eye-level marking 'sets'. The last alternative is that our eye level bisects the image, although not necessarily into equal parts, and therefore there will be some above and some below eye-level marking 'sets'. This last alternative occurs for example when an artist is seated but drawing from a standing model. It is appropriate to state here that our eye-level is parallel to the horizon, the horizon representing the farthest level that we can see across the ground plane. If the waist section on the standing model represents the eye-level of the seated artist, and this section is extended out each side of the figure the resulting line will represent the horizon, the distant end of the ground plane on which the model is standing. So our eye-level is where we can mark the horizon on our drawing if we wish to do so. Daumier sketched a low eye-level or horizon for the *Two barristers* (8), so as we look up at them, the unification of their image is maintained by the above eye-level marking on their hats. Watteau envisaged a high eye-level for the *Oriental servant* (12) and the unification of this image is obtained with the below eye-level marking on the shoes, we look down at them, and the drawn elipse of the carried plate, we look at it from slightly above. The eye-level here although not drawn is near the top of the format.

Here we have dealt with two fairly upright forms. For other orientation of forms, foreshortened perhaps in some angular direction, we must decide what kind of sectional marking is appropriate to their representation. Here I need to refer you back to the point where I asked you to make experiments with Gestalt groupings to which contours were added. You should now carry your experimental sketches a stage further, relating them to your sketch book studies from still life groups and natural forms. You need to continue working by the Gestalt groupings method but the aim should be to try and achieve as many different orientations of forms in space as you can imagine. See my diagram (49). It will always be sound practice for you to do this, either from imagination or from life. Only add the contours when you feel you have achieved the feeling of the form

and the kind of orientation or direction in space you want for it. Use as much pentimento as you like. *Don't rub out.* Start lightly or boldly, or try both. If you can find some tree trunks felled in a wood lying across one another work from these, or better still, find an old oak tree and make Gestalt groupings to represent the form directions of the main branches as they leave the trunk. An old oak tree is a wonderful substitute for a human model. To convince yourself of this look at Rubens drawing of a tortured man (41) turning the drawing so that the man's head is at the base of the drawing. The mans feet then appear to hang in the air and his left arm wraps round his trunk. You can see how the paper has been hollowed; the soundness of the sectional form analysis by 'sets' and how all the forms are securely suggested in spatial orientation or direction. The branches and trunk of a gnarled tree offer equal opportunity for this form of drawing analysis and practice at seeing forms as spatial elements. Helpfully, a tree does not move either.

If you continue with your experimental studies, as I have suggested, you should arrive at the point where you are able to recognise the direction of foreshortened or vanishing forms. You should also have reached the realisation of a golden rule in drawing which is that 'the outside edge of a form, its contours, are the result of knowing about its inside form'. It is ones understanding of the sectional shape of a form, its solid geometry, that enables you to draw a line or contour at its outside edge. The Gestalt grouping method of the analysis of form sections enables you to do this. In all your experiments with the grouping method I have asked for the contour last. This is correct because the contour expresses what you know and feel about the forms section, and the movement across the form.

Feeling directional movement
Establishing movement across the form is the first vital function in conveying figure movement, but of course at completion the directions of the various figure parts, trunk, arms,

and legs, etc., must also have been resolved. It is these directions that give the action of the figure.

So far we have only thought of the direction of forms in terms of very simple geometric ones. Mark grouping 'sets' have been related to the discovery of regular solids. Human forms are not regular solids, the nearest one could come to describing figure parts in geometrical language would be to say that they are rather like truncated cones, but having said that one has to realise that this is only approximate because the truncated cones are asymmetrical in character (bottom 49). Also although it may be possible to analyse one part of a limb in terms of certain conic sections, it will be rapidly realised that the next part of the limb will differ in conic section from the first. Look at the Cézanne (17), the Michelangelo (5, 26) or the Rubens (41) to reinforce this last point.

What we have to consider is the problem of obtaining the uni-direction of any form despite its diversity of geometric section. To be able to sketch the general direction of a form at the same time as using one's markings to convey its varying sectional content is one of the more skilful aspects of the arts of drawing. To draw figure movement well it has to be done, and therefore thought about and practised. Getting the general directions of figure parts right is an essential ingredient towards getting the spirit of the action of a figure's movements.

In sculpture when making a figurative clay model, one has to set about making a form of support for the weight of clay that is going to be used. This generally takes the form of metal rods called an armature. The armature rods have to be arranged in accordance with the general directional movements of the various figure parts being modelled. The armature rods are the central core of

50 Luca Cambiaso (1527–1585) *St Michael slaying the Devil* Pen, ink and wash (330 × 235 mm) *Victoria and Albert Museum, London*

80

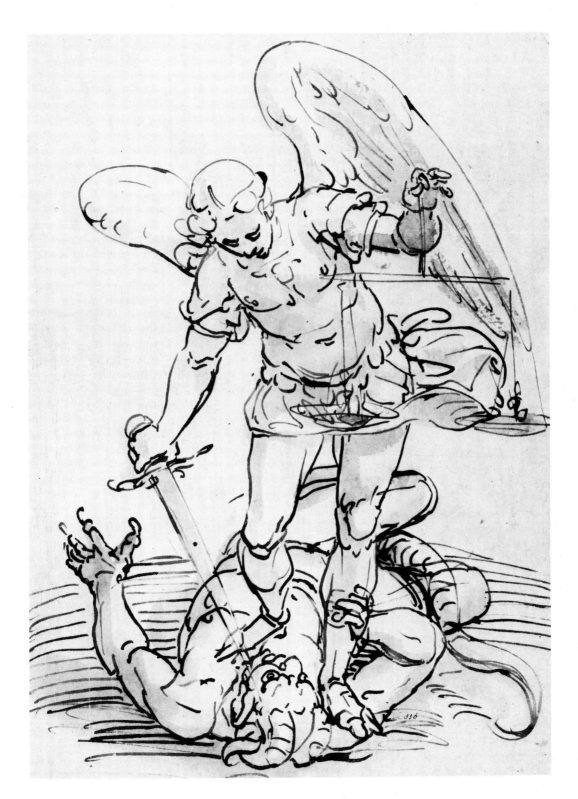

the modelling and so it has to express the general spirit of the action or movement of the figure being constructed. The armature for each anatomical segment has to be arranged so that it is as uni-directional as possible. That is the support for the mass of clay for a thigh takes the general direction of the thigh in space. *The armature that the sculptor constructs is really a form of drawing.* The armature is supportive but it is also a form of drawing movement in space and contains the simple story of a figure's movements. This sculptural conception is one that a draughtsman also needs. When we look at a figure in movement we need to be able to visualise an armature construction that would visually explain the variation in the general direction of its parts. So being able to sketch match-stick figures in movement in one's head or on paper is quite a useful piece of technique (51).

Of course the sketching of the uni-direction of a part must indicate the perspective of that part. The sculptor can arrange his armature physically in space. In drawing, imagining the paper to be hollow, we must sketch our armature so that it gives the illusion of three-dimensions. The drawing by Luca Cambiaso of *St Michael slaying the Devil* (50) is an excellent example of the construction of the illusion of three-dimensions in a drawing by the creation of a number of forms all of which vary in spatial direction to one another. Although there is no armature actually sketched in this drawing it is hard to believe that it could have been drawn without the artist first visualising the general action and position he wanted for the figures and therefore their parts. The devil lies on the ground and is seen in fore-shortened perspective, his right hand tries to resist St Michael his left hand illustrates the tension and terror in his imminent death. So his arms are in contrary movement. St Michael is poised above in triumph; he is balancing on his left leg which holds the devil down, while his left leg forces the breath from his adversary's body. Trunk and head bend forward over the devil whilst a strong right arm

drives a sword to his throat. The left arm comes forward to the drawing surface, in clever foreshortening, the left hand holding the scales of justice. This drawing of St Michael probably contains a greater variety of form movements in its parts than any other drawing reproduced in this book. As I have said there is no indication that an armature was sketched on the paper to establish the figures' inter-connected movements, but plainly they were planned at some stage. If they were only 'drawn in the mind' and never reached the paper, they were still vital to the drawing, its integration and the story it tells. Certainly sketching the general direction lines for forms is a useful way to plan a drawing when learning, and of course it ensures we can feel the spirit of the movement. The drawing of directional lines can also be arrived at by the use of pentimento, because sometimes quite a few lines are needed before the correct direction is established (52). I have included a number of drawings where I have used and left directional lines, and in these drawings there is much of pentimento in directional lines and sectional markings. Directional lines are followed by marks which determine the sections of forms, and the drawing of a part is built up by more form sections relating to the general direction.

Study the drawing of the legs in Rosenberg's Back view of a nude (28). All the markings give the various sections of the thighs, knee, calves and ankles, but at the same time indicate the general directions of the legs, and in any good drawing you will find that the sectional markings do not detract from the spirit of the general direction the form is taking. Examine Filippino Lippi's *A nude man* (19), Raphael's *Man fleeing in terror* (11) or Michelangelo's *Flying angel* (5) and you will find the same control in all the artists' markings. From a graphic point of view the general direction or orientation of a solid is one of its more vital properties. My drawing of a young woman in costume and hat (53) was made as a demonstration for a student. To the right of the drawing as I built

51 (i)

51 (ii)

52 (i) and (ii)

52 (iii)

it up, I drew the general directional lines for the various forms of the body parts as I analysed them. You can see that the spirit of the movement of this figure took a flattened S shaped rhythm. Although many sections have been analysed the general spirit of the movements within the figure have not been lost. In this drawing a light ink wash was applied over the pencil. I did this to bring all the markings on the inside contour together so that the student could see the head and trunk forms as a simple unity. The general directional lines sketched on the right of this drawing are always something that can be done to make eye-level sections and form directions clear to one's self. They are part of one's working technique, and can be drawn in or round the drawing one is wishing to complete.

Space and spatial characters

We first of all create space when we are drawing and imagining the paper to be hollow. It has infinite space until we place down marks and forms which in some way impose limitations and make confines. One way of doing this is to draw a horizon line, a line which defines how far we can see from the position we have adopted, or else we mark off the far edge of a ground plane which is produced could carry on to the horizon. Looking at Toulouse Lautrec's *English dancer* (20) we can see that a ground plane has been very clearly defined. A boarded floor is represented which starts below the bottom edge of the format and is the ground plane which we are on. It moves forward under our line of sight until we see it entering the drawing, where by diminishing distances between the floor boards its perspective is made clear, until it ends at a horizontal at the level of the dancer's right knee. This horizontal confines the space we are asked to believe in. The space created starts with the space round us the spectator, it is cut off left and right by the perpendicular format edges, although we can feel that it would be possible for the dancer to go off to the left or right, and the depth of space is that of the depth of the

53 597 × 337 mm

floor. The figure therefore dances in a space that we can understand, very clearly the space drawn here is made part of the image. The form movements of the dancer and the space are mutually enhancing. Space then is something we need to be as conscious about as form. Where there is form there must be space about it; where there is space there is the possibility of creating boundaries or confines to limit it in some way, or of placing forms within it.

Cambiaso's *St Michael slaying the Devil* (50) general space mechanism is much like Toulouse-Lautrec's only the ground plane is drawn rather more freely with a bold pen-line. We have a common ground plane with the struggling figures so we can believe in the space in which they struggle, although the ground plane does have a rather indefintite far edge which hints at seeing the horizon of the world's surface.

In Rosenberg's nude woman (28) again we share a common ground plane and so can fit the figure movement into believable space, but in this case the ground plane is not drawn, rather suggested. The two feet are depicted in a related perspective walking on the ground and so in our imagination we can walk with it. The limitations here is that the feet are placed firmly on the ground, and that the poise and action of the figure takes place between them. In a number of the drawings in this book the ground plane is not marked in, but if they are examined in the same way as the Rosenberg it will be seen that the artist did have a clear idea about a ground plane or a seat for a figure in relation to it. In the early learning stages it is best to get used to the idea of indicating a ground plane on which ones figures can be placed and the space felt about them. I would recommend the Cézanne *Male nude* (17) as a very good example of what I mean. This figure stands firmly on the ground. Cézanne has really made sure it does by very deliberately drawing some of its cast shadow on to the ground's surface, and by the use of the shadow one is helped to believe in the solidity of the forms of the figure above and the space around them. A shadow used where a foot makes contact with the ground may seem just a trick but it is also a positive way of recognising space.

When drawing figures in movement it is necessary to be able to judge the general direction of their various parts in space. The directions of the armature parts. Space will be *confined* between the figure parts, and the parts and the ground, and these will give the spatial character of a movement. It is possible at times to look more at the space confined by a figure than the figure itself, when drawing movement the space between figure-parts becomes as real as the forms of the figure. De Segonzac's statement about the man jumping from the window sill, that we considered earlier, covers both the concept of form and the concept of space. To be able to sketch a man jumping before he hits the pavement below means we must be able to make a rapid overall appraisal of his position, by trained looking we seize essentials of form and movement. But we cannot seize the essentials of form and movement without also apprehending space. See my sketch of the essential character of a man jumping (24). To have a mental concept of this kind the consideration of space is all important. In the sketch there are a series of parallelograms all of which represent rectangles in perspective. There is a rectangle between the lower two arms, upper two arms, lower two legs and so on. The armature lines that represent the figure's movements are also boundaries of the space between the limbs. So in the process of conceptualising this figure limbs and body parts are visualised as providing boundaries to space – there is *space conception* as well as *form conception*. We can take this a stage further by conceiving a space plane, the four corners of which are the man's elbows and knees. Then we have a plane parallel to the trunk plane and we have now conceived a cubic form of space confined by arms trunk legs and the elbow and knee plane. When I referred previously to the idea that it is possible at times to look more at the space confined by the figure than the figure itself it was this kind of example I had in mind. To go

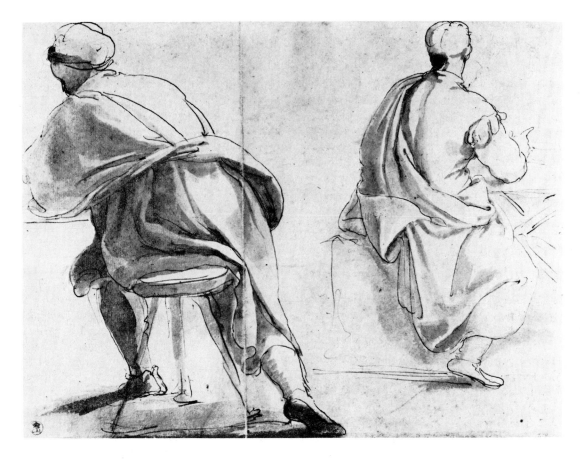

back to the jumping and space we can find other near cubes of space between arms and head and between legs and ground. So the wonderful usefulness of de Segonzac's statement is that it can be a continual reminder of how form and space should be interlocked in the conception of three-dimensional images and their movement. Often whilst teaching I find myself saying: 'draw the space, draw the space between the forms'. I say this because I know that by perceiving how space is confined we are perceiving how the parts of the form of our image are related in space. We must be aware that we are always searching for the simplest form in which to present our image, and the interlocking of space with form does offer the possibility of simple structure. Also if space is intrinsically part of an image then it must be included in a drawing statement of its description.

54 Anonymous fifteenth century, Italian *Man seated at table* Pen, ink and wash (210 × 273 mm)
Victoria and Albert Museum, London

Not all expressions of human form movement in action have such a clear and spatial character as the de Segonzac example, but nevertheless there will always be some enclosure of space. Raphael's *Man fleeing in terror* (11) could be taken as an example of a more usual kind. The left leg of the man casts a shadow to the left and so we are made aware of the ground plane on which the man is moving. From the planting of the left heel to the pushing down of the big toe on the right foot we are made aware of the fact that one foot is spatially behind the other. If we then

follow up both legs to the crotch we realise that Raphael has perceived a triangular space plane between the legs whilst concerning their form. This is much like the Rosenberg drawing in reverse. The more powerful expression of form movement is in the upper part of the figure. Here the man's trunk is made to bend towards us, the hand nearly appearing to come out of the drawing at the top. By the form and bending of the trunk we are made aware that we share a common ground plane with the figure which is coming forward to our right. I believe that the shoulders and head come forward because, whilst he was drawing, Raphael conceived a plane of space that commenced at the man's two shoulder points near and far and then which dropped perpendicular cutting the ground plane somewhere between us, the spectator, and the figure. Thus the trunk form was felt by Raphael to be moving forward with its front plane 'looking down' to the ground. So the conception of space in front and underneath the figure was used by Raphael imaginatively to grasp the simplest three-dimensional meaning of the image he was inventing as was possible. The possible complexities of the foreshortened anatomical rendering of the trunk are thus simplified.

The very exciting anonymous fifteenth century Italian drawing of a *Man seated at table* (54) is another excellent example of the use of the interlocking space and form conception to give simple structure to an image. It is in essence almost the reverse of the Raphael the man moving away from the spectator as he leans from stool to table. The spatial position of the feet is strongly marked in both cases by a vivid dark wash. Therefore there is no doubt that he is moving away from us diagonally. His shoulder points are perpendicularly above the table edge and his bent left knee is also more or less in this perpendicular space plane if one imagines it dropping through to the ground. The wash on the garment coming back from his left shoulder makes an inside shadow contour which, with the outside contour to the right, draws the plane of his back, the near portion of

which is over the stool and the far portion over the table edge. This plane acts like a bridge over the form of the man's trunk and the space below it to the ground. Altogether a wonderfully conceived and executed drawing of form movement and space.

Feeling the form

Michelangelo had both a passion for drawing and a passion for form. To draw well it is necessary to have both. Every object which we wish to draw is a form and it is the shape of the form that gives it its individual dynamic and arouses our feelings. As all forms have some solidity their shape is learnt not only from their outside edge silhouette, but from the variable nature of the surfaces they present. The outside edge of a cube tells us it is constructed by straight structures, it is only when inside surfaces of a cube are examined, that is any two together, that we see the straight structures are planes that are arranged at 90° to one another. The planes are in three-dimensions and the dynamic of the cube is that the planes express direction or force. The cube overall is therefore a diagram of forces, moving in height, breadth and depth. Any piece of drawing of a solid image will express some of the plane directions from which it is constructed. It is during this expression of plane directions that one needs to feel the form. A draughtsman develops empathy for a form so that being at one with it feels the directions of all its planes and therefore the diagram of forces that gives it life.

I believe it was Cézanne who said: 'When I paint an apple my eye is inside the apple'. Drawing is just like this, one is both outside and inside the object one is drawing. Feeling for form is gradually generated, it comes from one's passion for drawing. Generally speaking feeling for form first comes from the

55 Auguste Rodin (1840–1917) *Femme nue assise – Nude woman seated* Pencil, with some rubbing; on off white (unevenly discoloured) wove paper (340 × 274 mm) *Courtauld Institute Galleries, London*

56 Rosalind Woodroffe 559 × 381 mm

creation of a tone on the paper. To the first Gestalt sectional markings other marks are added, some pentimento, and some for reinforcement. This tone created by marks will be built up to represent an inside contour of a form, or the edge of a shadow plane against a light plane. As it develops so should the feeling for movement across the form and then of course the feeling for the whole form. The Rodin *Nude woman seated* (55) although a very delicate drawing gives a most firm rendering of the forms of a woman's body. The head, arms, breasts, abdomen, buttocks, thighs and calves are all given this 'firm'

rendering by a feathery type of pencil technique which caresses each form in turn. The technique is light yet the intention behind it very strong. A strong feeling for form in fact. Somewhere that strong feeling started from a light tone feeling for a form section. It may not be possible in the beginning to work so lightly and achieve such resounding results. It does not matter if first drawings are very dark as long as they end by expressing the form and movement you want. In this connection it is unavoidable not to look in the direction of Michelangelo again. The chalk drawing studies of the crucified man (26) has

many inside contours created by numerous reinforcing marks until they can be seen boldly against the lights. It is this form of searching analytical drawing that will develop the power of feeling the form. The mark building can become quite dark but it will still work if the planes on which the light falls are kept clean. Struggle therefore as much as you like with inside contours to feel the form but preserve the lights.

The woman seated (56) is a drawing by a student. It is quite dark and heavily overworked in places. However the black pencil marks build up to 'forceful nuances' and express a feeling for the form of body parts. Some lights were rubbed back in with chalk to help to preserve them. Altogether a very successful drawing born from struggle and pentimenti which produced a very cohesive and dynamic result.

The Degas *Study of a nude girl* (57) shows how successful the 'preservation' of planes on which light is falling can be in the construction of a drawing when other planes have been marked over to give life to inner form. Quite vigorously Degas has excluded upper face, chest and arms from form feeling. They not only express the light and direction from which it comes, but form a wonderful corollary to the simple round forms of neck, lower face, abdomen and hips. The form modelling is aided and abetted by those mystical and apparently simple directional contours of which Degas was a master. Movement in this drawing is expressed by the simple uni-directional quality of the individual forms. The overall impression is one of conviction of ideas and restraint in execution.

Contours

Many artists have felt that one of the most essential elements in drawing was a sense of movement, born from a sense of form. Movement is inherent in form because every solid form exhibits a diagram of forces the most dominant of which gives the form its general direction. The general direction is the longitudinal axis of a form. In the accompanying life drawing and sketches I have shown the axial directions by arrows with additional marks for the enclosing contour directions (58). The axial directions are the dominant force 'felt' between the outside contour. Our feeling for movement is thus energised by this dominant force and as we put down our marks to feel the form sooner or later we want to draw its outside or contours. Movement of form is finally captured in the contour. The outside edge or contour is the result of the inside form and the vital energy it contains. In a contour we are looking for something special, for a certain quality of line that both expresses the inside form but which also has a style and a meaning of its own.

These kind of qualities are apparent in the Degas (57) that we have just examined. In the Matisse *Nude standing* (59), we have an example of a pure contour drawing. Matisse was a master of this style of drawing. He was able to create contours which conveyed the essence of form, its general movement and direction in space. The left arm of the girl in this drawing is quite startling in its clarity. The muscle formation is acutely felt within the single contour line which in a continuous stroke also incorporates the bones of the wrist portraying their squarish hand character. There is therefore a change of meaning in the contour as it passes from muscle to bone. Such contour drawing is line drawing at its most talented best. Perhaps one is baffled by its superb quality. The life studies that Matisse made as a young student were not much different in appearance from the Cézanne life study shown in this book. Matisse had an 'apprenticeship' in formal academic drawing, and this training in form drawing and movement must be seen as a prelude to his later linear style. Such contour drawings come from long practise at feeling form.

During the process of making marks, the extended mark is used as a line and when it.is extended to enclose a form it becomes a contour. The development from marks to lines and then contours can be seen in Ingres' drawing of a girl playing a musical instru-

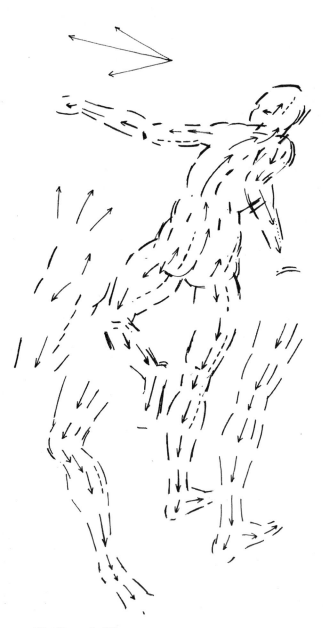

FORCE I.

RESULTANT DIRECTION

FORCE II

58 (i) and (ii)

57 Edgar Degas (1834–1917) *Study of a
nude girl* Pencil (391 × 192 mm)
The British Museum, London

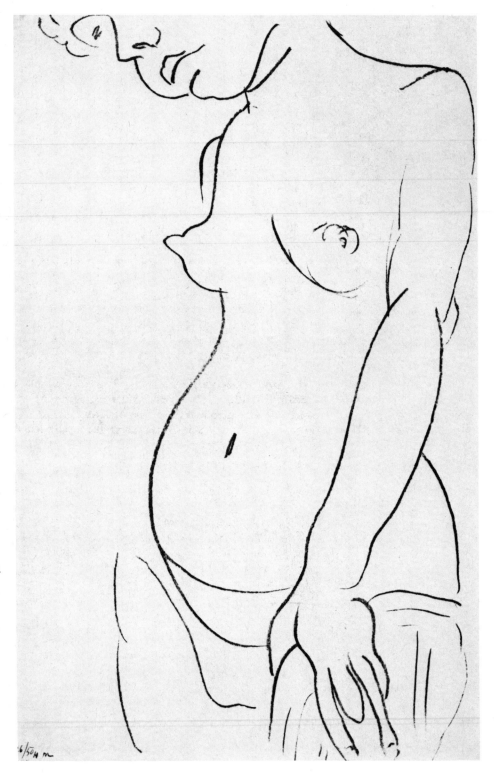

59 Henri Matisse
(1869–1954) *Figure
debout – Nude
standing* Lithograph
(495 × 325 mm)
*Courtauld Institute
Galleries, London*

**60 Jean Auguste
Ingres** (1780–1867)
*Sketch for
L'Odalisque*
Black Chalk
(445 × 336 mm)
*The British
Museum, London*

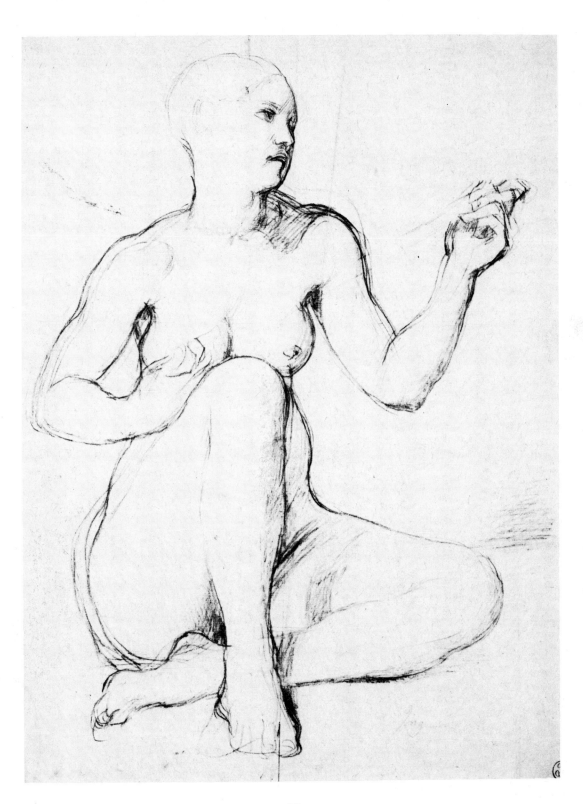

97

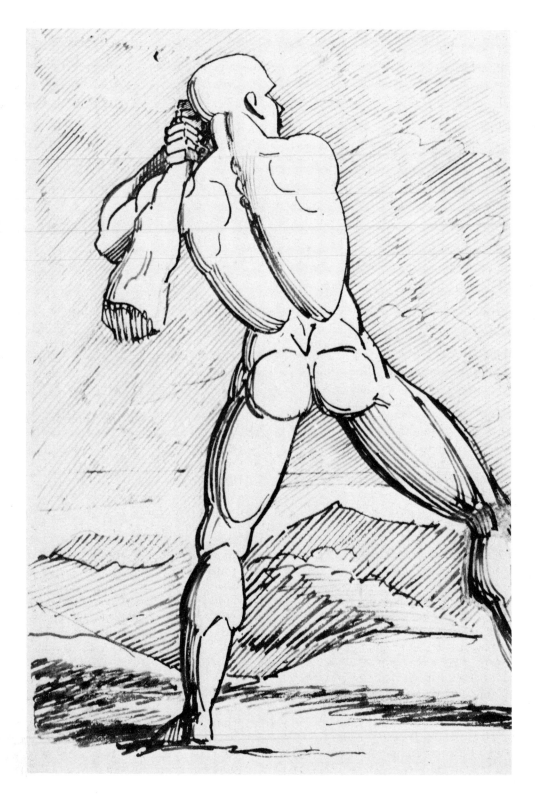

ment (60). Some of the first marks suggest movement across the form, or are feeling for form. These can be seen on the face, base of the neck, chest and underneath the raised right thigh. Their aim is to establish planes or feel bulk. Other kinds of marks then arise which are used to depict cast shadow and feel form by bracelet movements across the form at the same time. The shadow of the head on the shoulder and the right leg onto the left leg does this. Drawing cast shadow is a dangerous practice but here it has been accomplished by using it to represent form section and also assigning it a decorative role within the drawing. The contours are undoubtedly generated in sequence from Ingres' feeling for form growing from these marks. In many places there are a number of repentances which add to the life and movement of the drawing. The upper right arm outside edge is determined by four or five lapping contours. The determination of meaning for the final form edge lies somewhere between them. So the final edge is more suggested and left with the imagination rather than being definitely cast in one line. This very natural ploy gives the drawing a sense of life and vitality. The drawing is a very large one and very impressive in the manner in which the multiple contours are both used to convey movement and at the same time turn the rather large spaces between them into solid form.

With the Fuseli *Male life study* (61) we have another use being made of the multiple contour. In the fairly violent and rather schematic anatomic rendering, the individual segmented forms have been felt by a series of strokes that lie along the form, lighter on the inside of the form and darker towards the edge. Although these strokes are not bracelets, their change of tone and the manner in which they are merged towards the outside edge provides a modelling force.

61 Henry Fuseli (1741–1825) *Male life study* Pencil, pen and ink (314 × 203 mm) *Victoria and Albert Museum, London*

This drawing is worthy of further study if only from the point of view of observing its assured use of the pen. Texturally it is also very fresh and simple, the landscape and sky marks are also opposed to the action of the figure in a most dynamic fashion.

I have included the next drawing by John Gibson (62) because this is a manner of working which many might attempt or wish to experiment with. All the preliminary or first stages are in pencil, and if we look to the right and the bottom of the drawing there is a feeling that much of this fluid sketching is automatic, that is involuntary; the artist appears to be groping about for his forms. Consequently movement is suggested in the abstract by many fine multi directional lines and then gradually anatomical forms emerge, particularly the surface form of individual skeletal muscles. Finally contours are determined with pen lines from the preceeding suggestion of form movement. This is a technique worth trying if only to discover to what degree it might suit on a particular occasion.

The contour in the Guercino *A woman about to bathe* (63) is different again. The pen has been used fairly directly and there are not very many repentances in the contour drawing. What is so important here is that the artist's sense of light has been the dominant factor behind the technique for capturing the form movement. Planes that turn away from the light have been effectively and hauntingly suggested by washes of shadow tone. The light moves in from the top left and the shadow planes are built up against it moving from bottom left to top right. The wash is wonderfully fresh, but it conveying an accurate sense of the roundness of a female body. The drama of the head is profound and reminiscent of early Picasso. The transient and suggestive nature of contour has been obtained in this drawing not so much by repentances but by breaks in its contour line. Down the right hand side of the woman's trunk breaks have been employed so that pieces of outside edge relate to portions of inside form. The breaks in the

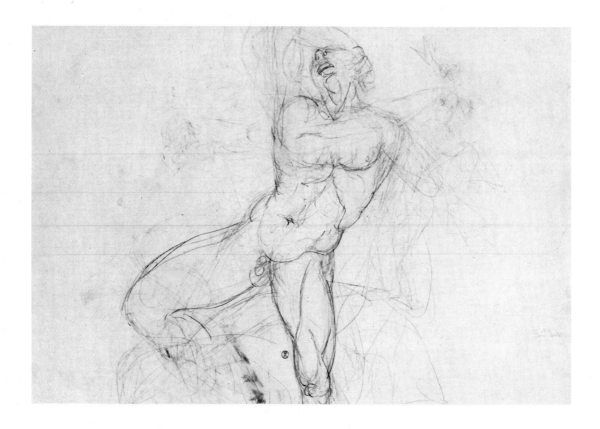

contour allowing the light to flow through and play on the inside top surface of the forms. Looking at the drawing with half-closed eyes will aid in its appreciation. There is a degree of automatic drawing as well in the drapery on which she sits and also in the drapery she holds above her head. This last must have been accomplished in seconds and contains wonderful insights into the renderings of cloth and movement.

Pollaiuolo's *Hercules and the Hydra* (64) is rendered with inside and outside contours. Breaks are employed in the outside edge or there are nuances that attract the eye to the more important parts of the anatomy such as joints or main changes of direction. A very rapid drawing in which one can feel the contours hacking out the forms and suggesting their direction in space. It is very much a drawing where the artist has been anxious to capture a sense of movement immediately and not be over concerned with anatomical

62 John Gibson (1790–1866) *Life study*
Pencil and pen (356 × 483 mm)
Victoria and Albert Museum, London

63 Giovanni Barbieri 'Guernico'
(1592–1666) *A woman about to bathe* Pen drawing with bistre wash (266 × 209 mm)
The British Museum, London

accuracy. The marks on the torso are well worthy of study. The centre twist is beautifully felt, the marks expanding out across the chest and lower ribs until they are balanced by the outside contours.

I have included two Ingres drawings, because I considered they would be an effective visual aid when writing on the elusive subject of contour. Simple, meaningful and accurate contours are what we would all wish to capture in our drawing. Ingres was an artist who was able to use the sinuosity of

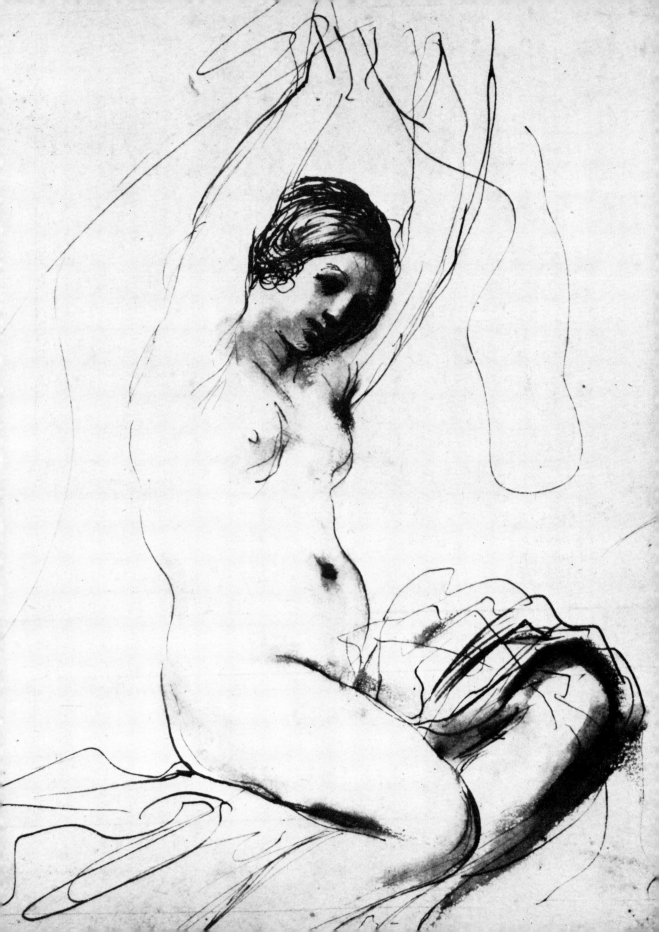

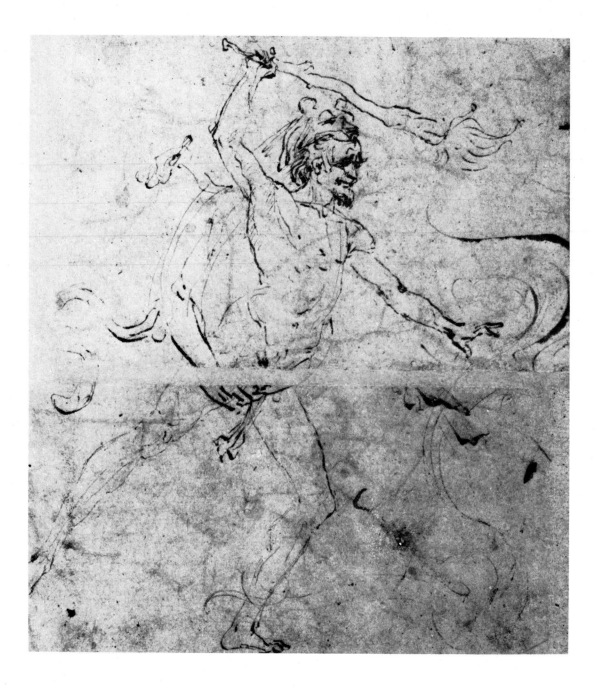

64 Antonio Pollaivolo (1432–1498)
Hercules and the Hydra Pen and brown
ink (235 × 165 mm)
The British Museum, London

65 Jean August Ingres (1741–1825) *Study
of an angel* Pencil (348 × 242 mm)
The British Museum, London

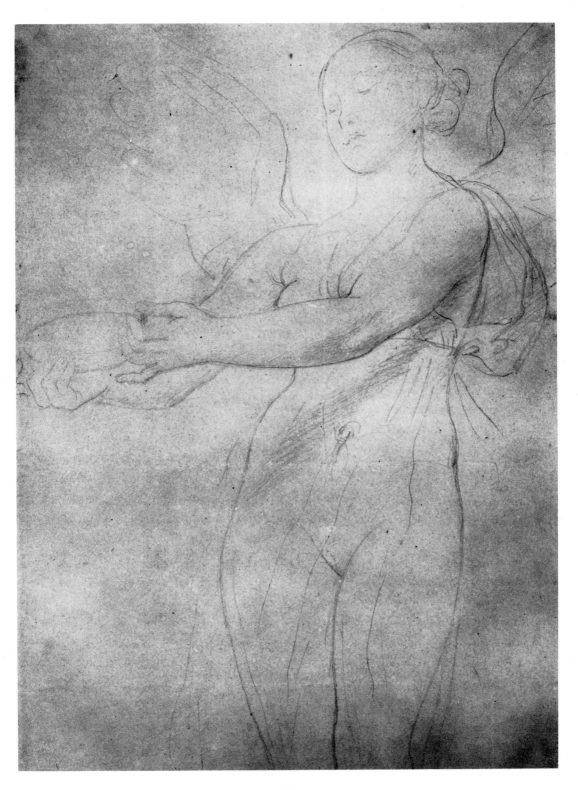

103

line to capture both form and movement. The sinuosity never ran riot, but explored subtle curvatures which for much of their path seem to run in straight directions. His contours therefore show elegant restraint as well as strength. In his *Study of an angel* (65) all these qualities can be found. The cast shadow across the front of the body reveals how Ingres conceived form when drawing. The conception was always of simple unidirectional forms. The shadow reveals that his idea of an arm was based on a long slender cylindrical tube form projecting into space. At the same time we can see if we look at the near outstretched arm that the individual muscles were not ignored. The muscle detail is rendered in relation to the general form direction and is not obtrusive in any way. The restraint and skill with which the contour is drawn becomes clear. All the minor changes of direction needed to draw muscle shape in the contour are accommodated within its general direction. Look at the back and lower edge of the nearest outstretched arm; in the rear upper arm the tricep muscle is represented by the slightest change of direction from the general direction of upper arm from armpit to elbow; in the lower arm the finger flexors hardly deviate from the general direction between elbow and wrist. Yet the flesh of the muscles is discernible and depicted by the most subtle of curvatures. One must remember on this subject of subtlety of curvature that to achieve its mastery it is the natural form of the body that has to be studied. Ingres merely points the way. I believe it was Cézanne who gave a wise direction on this when he said 'he did not want to be right in theory but in nature'. Any part of the Ingres drawing can be studied so that one may learn the skill of drawing subtle curves. There are only minor changes of direction in the majority of them and the outside contour proceeds effectively in a series of straight edges making major changes of direction at only a few positions. Excluding the head and knees there are really only six major changes of direction in the whole drawing, one at each shoulder

point, one at each upper hip point, and one at each lower hip point. This simple selection demonstrates the high standard of taste and skill that Ingres was able to bring to the meaningful drawing of contours.

The drawing by Kolbe is perhaps the glorification of drawing figure movement by contour alone (66). Inferior perhaps to Ingres in cursive quality and classical taste, it nevertheless is affected by the classical idiom. After the First World War, Kolbe made many drawings of the young nude body in motion. In this very successful drawing one notices at once that the main changes of direction in the contour are cut to a minimum. With all the minor changes of direction played down the drawing makes a simple dynamic exploration of shape that would be hard to better. Because there are so few major changes of direction in the outside shape, Kolbe has been able to reduce the different directions of the outside edges of the main forms down to a very small number. The brilliance of this drawing stems in part from this technical achievement. It seems to me that the drawing consists of only five different directions. One is the direction of the outside contour of the bent right leg; this is repeated in the abdomen, the muscle of the bent left leg and base of the neck and shoulder line. Two is the inside direction of the bent right foreleg which is repeated in the upper contour of the left thigh and shin of the left fore leg. These last directions make a wonderful oblique compositional direction right through the base of the drawing. Three is the direction of the right arm repeated in the left breast and left forearm. Four is the upper left arm and back of the head. Five is a general perpendicular direction felt in the left hand side of the chest wall. To me perhaps this last direction is the most technically profound, because by being static it provides a central contrast to the other four dynamic directions moving round it.

This drawing is a superb example of movement captured by contour. As I have just explained, its diagram of forces by directional lines is simple and therefore its gain of

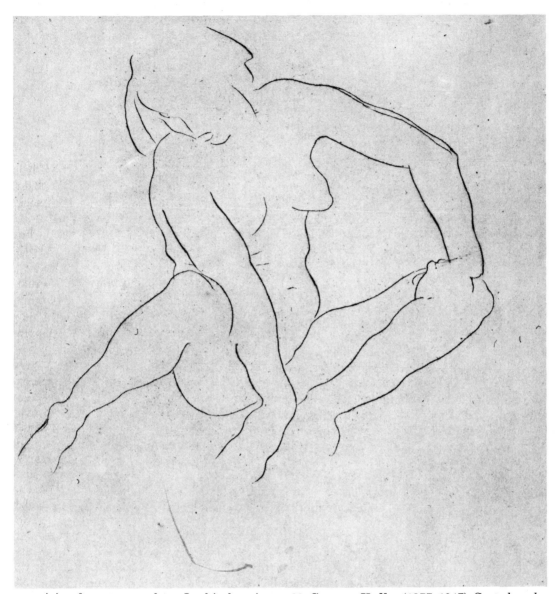

energising force tremendous. In this drawing
we have a record of some very special line
quality that truly has a meaning of its own.
Its contours express many small individual
rhythms but they have all been adjusted to
reinforce the general spatial character or the
spirit of the overall figure movement. Con-
tours can be used very fluidly with many tiny
rhythms being created, but in the best work
the sense of the general direction of a con-
tour is never lost. It is virtually certain, as we

66 George Kolbe (1877–1947) *Seated nude*
Drypoint, on white wove paper
(410 × 328 mm)
Courtauld Institute Galleries, London

can see from the Kolbe drawing, that by
constructing a drawing showing clearly the
main changes of direction in the contour the
essential spatial character of a movement
will be enhanced.

4 interpretation and vitality

Style and imagery

No one artist has a monopoly of all the images that could be produced from the human figure. It will always provide endless visual material. I am constantly amazed and delighted by the fresh approaches I see in the life room from students. There is always the unexpected and the new; an artistic statement not seen before. In my teaching I have never been primarily concerned with style, rather the aim has been to increase the power of perception with the methods I have previously explained, and at the same time further the use of the imagination and experiment with mediums.

I do not believe it is possible to define an image in advance, to attempt it would destroy so much of one's perceptual potential. Although in drawing use is made of perceptual patterns so much can happen in the process of discovering a solution that it is not possible to predict the appearance of a completed drawing. The completion of a drawing depends on a continual enrichment of seeing as the work proceeds, but as well on the personal expressive powers of the artist. The completed solution will be a particular artist's style. Oldenburg defines style as being 'a practical and functional solution which may or may not draw on previous styles'. Style in the universal sense is not achieved in one drawing but rather in a series of consistent drawings in which it can be seen the solutions were governed by similar technical controls and imaginative developments. Whatever the style of a drawing may be, and from whatever historical period it comes, one can be sure that if it is reasonably well known other works rather like it will exist, and its style will be recognised by its consistency of method.

Style should not worry us too much. For what it is worth once we have discovered a consistent manner of working, we have a style. The drawing process is ideal for creating new images and to indulge in fancies and so styles may change. The impact of new surroundings or fresh ideas on the imagination may cause a stylistic shift.

New images are created from imaginative insights, so that vision and style are inextricably bound together. The presentation of a new vision needs a technical method over which one has control. In Wyndham Lewis's drawing *Demonstration* (67) he conducts an assault on our visual sense, but his mechanistic semi-abstract presentation is under complete technical control. The style and the vision complement one another. Lewis was a Vorticist, he subscribed to an artistic philosophy which had Activity, Significance and Essential Movement as its watch words. *Demonstration* is a harsh image which demands our attention. The directions of all its parts are passionately dynamic and full of movement, and there is a restless activity in the pen markings. Dark hatching stabs and scratches out a stark harmony. It is a con-

67 Wyndham Lewis (1884–1957)
Demonstration Ink (235 × 174 mm)
Victoria and Albert Museum, London

106

107

troversial work as it was meant to be, but its vision and its style are compatible.

The personal approach

We must learn about techniques and methods from others, and in looking at and examining other artists' work, past or present, we determine our taste for certain types of drawing. We have favourites either because we like them, or because we find them easy to learn from, or both. We must continually attempt to put into practice what we have seen. It is when we do this, set about marking and hatching and line making that we are faced with our personal manner of working and expression. What we manage to do, and just how we do it, is unique to us. We must face up to this fact and endeavour to make good use of what we have, for in the end we must resolve a drawing in our own way by ourselves. A finished drawing contains something more valuable than finish, it is a complete solution compounded from ideas, mediums and attitudes.

One of the things we should do before starting work is to lay out as many different drawing materials as possible. Pencils of different kinds, pens, inks, crayons, chalk, charcoal with different sizes, colours and qualities of paper. Not as a once for all try out because artists' drawing methods change over the years, but at least we should attempt to work with a range of materials readily available. From continual try outs, we can learn if a small mark is friendly or a larger one better. Combination of different mediums should also be tested, penwork with pencil, crayon with charcoal and so on. Personal expression by choice of medium cannot be dictated. Try outs enable each individual to find the most expressive mix, and nuances of meaning which only they are capable of.

Somehow one has to become submerged in a drawing and find an easy spontaneous method of execution. Being at ease with drawing mediums, knowing what they will do when you use them up is a great help towards this end. To be aware that a particular blackness or greyness or textured effect is available is a tremendous aid in image making. If I start a drawing with a fine pen or biro I am aware of the range of markings I can obtain, a small cloud of textured marks or separate fine lines and so on. I am further aware of how they may change in appearance if I add other mediums. This is fine and is one of the more enthralling facets of drawing. The drawing becomes yours or mine with its own vitality and significance, and by its clarity and directness gains the attention it wants (68). This is a rapid study made in three or four minutes to show a student the possibilities of drawing with a felt tipped pen. The mark made was therefore broad and coarse, and the figure subject was strongly lit from the right. All I could do in the time available was to calculate main directions and with half closed eyes summarise the simple effect of light and shade. Because of the width of the felt tipped pen I chose to render all the planes turning away from the light by diagonal strokes. I left wide spaces between the diagonals to lighten the weight of the drawing and to increase the sense of movement. The proportion and spacing between the marks was very much dictated by the thickness of the felt tip.

Another quick study made for a student (69). This is drawn with black biro and was scribbled down needing a lot of mechanical effort to create the dark areas. The main aim was to catch the movement of the coat and umbrella by repetition of line, and indicate hair and facial features. I find that biro pen can be an exciting medium to work with because many fine lines need to be countlessly applied to repeat a movement over and over again.

In this drawing my mediums were pencil, biro and red conté crayon (70). All my drawings for students, as well as the students' drawings, were done in a strong unidirectional light. I used pencil to gain the first movement and proportion of parts and then applied the conté crayon and biro. The biro gave some texture and the conté-crayon broadly suggested the shadow planes and

68 597 × 413 mm

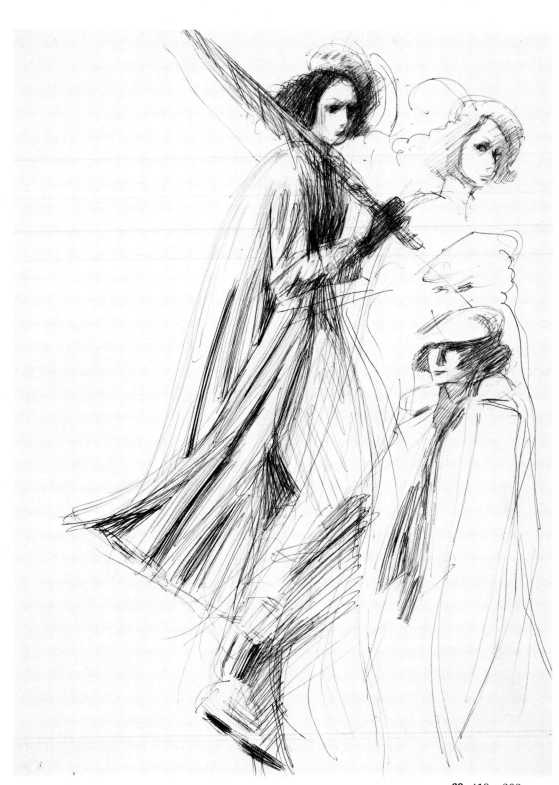

69 419 × 298 mm

70 413 × 298 mm

71 419 × 298 mm

inside edges. This again is a very free drawing and was quite spontaneously invented with the three mediums.

Another rapid demonstration study (71). The drawing is in HB pencil. The main challenge was the movement of the girl's coat, the perspective of her face and her hair shape. Much excitement had to be generated in a short time to motivate the countless strokes and lines needed to express the movement.

This is a study by a student but left at an early stage (72). It is quite small, made on grey paper with a heavy piece of charcoal. I think it is a very beautiful drawing. All the nuance marks relate to each other by line marking generally in diagonal directions. Visually it is most attractive with a lovely sense of animation. It shows what can be suggested on a small scale with a large mark if one's drawing aims are clear. These five drawings together give an idea of the variety of effect that can be obtained from medium experiment and involvement.

Drawing techniques which combine a number of mediums are extremely useful for other reasons. For one thing they give insights into how we may expand our range of expression, and for another they allow us to work by a process of correction, where the corrected parts are allowed to remain in the final image although subservient to marks laid over them in another medium.

As an image is developed so the draughtsman's feelings about it change. Certain parts become more valuable than others and so more forceful nuances are required to establish their priority. Finally the image is felt to be a whole and the drawing is complete. Second and third mediums over a first can provide extra visual 'weight' and so be sure of claiming attention. The completed drawing can be finalised in the most dominant medium. This of course is a further use of pentimenti. The markings in the second medium being a repentance of those in the first and so on.

The improvised figure composition

An exciting field of invention in drawing which also greatly aids feeling for figure movement and its depiction is imaginative figure composition. Improvised composition can grow from the slightest pretext, the subject matter need not be extensively researched. The idea being simply to draw figures as freely as possible related to one another, but at the same time covering a wide range of figure movement. I have chosen three drawings as examples of this type of work. David Bomberg's drawing entitled *Struggling figures* (73) searches for the most intense expression of movement and activity. Bomberg said his aim was to seek 'the spirit of the mass'. Throughout, although freely wrought, strict attention has been given to the arrangement of the forms. One imagines that the drawing grew out of the development of the essential diagonal movements, other diagonals being added in opposition here and there until a series of triangles and parallelograms materialised and the visual activity was increased. In the drawing, Bomberg discovers a fresh use for the depiction of figures by simple geometric mass, anatomy being sacrificed to gain the spirit that he needed. Each small part of this drawing is worthy of close study because every detail contains a variety of forms executed with an intensity of feeling and charged with meaning and energy.

Keith Vaughan's *Landscape with figures* (74) gives another view of the improvised figure composition. This work was carried out at a time when the artist was influenced by Cézanne's ideas on figures in landscapes. The figures have their own natural grace. Formalisation has not been taken so far that it entirely destroys a sense of muscle and flesh. The curves of the bodies are reflected in the curves of the tree branches behind. The imaginative free pencil work that has been used in various enclosed areas between limbs and bodies should be studied. The technique is very varied and has been used without any affectation to give unity and meaning to the piece. It reinforces, or dynamically opposes,

72 Jenny Evans 381 × 229 mm

114

curves in the figures and helps to animate the whole.

Duncan Grant's two *Trojan women* (75) is not strictly drawing as it is executed in oil painted body colour, only the preliminaries being in pencil. However, Grant's main concern has been to visualise his thoughts about dancers, and the oil and body colour does not in any way obscure the arrangement of moving lines he used to do this; therefore this work can be considered a drawing. The vitality of the work is typical of the artist who found much to interest him in the dance and ballet. The decorative quality owes something perhaps to Gauguin and Matisse and its simplicity of figure forms to his interest in fifteenth century Tuscan painting. Nevertheless his style is not obviously derivative, and this work has a freshness and an appearance of 'lack of labour' that is characteristic of him. The three figures

73 David Bomberg (1890–1957) *Struggling figures* Black chalk (483 × 682 mm) *Victoria and Albert Museum, London*

moving in harmony and the ideas of linear expression derived from them, come across delightfully and any exaggeration of shape is fully justified by the overall effect.

As a final example of the improvised figure composition I have selected a different format. In the *Rape of the Sabines* by Ceri Richards (76) the artist has divided his format into ten parts. The artist presents us with ten shots or frames of the rape. They are not in close sequence but rather offer separate visions of the event. The complete set has a restless dynamic which is enthralling. Tonally the frames are in different moods although they are all composed on strong diagonals. The change in tone is effected by

the use of varying drawing materials. The weightier tonal effects are achieved with the use of ink, watercolour and wax crayon. In the lighter drawings water colour has been added to a penline. In the lightest drawing, the second one from bottom right, a watercolour wash has been added to a pencil line. Visually they do not read like a printed page but rather the eye is drawn here and there at random. In this strange work, tragedy is blended with feelings of tenderness, and one is reminded of the surreal aspects of Miro and Picasso. Such a work is worthy of attention because it suggests how visual ideas of movement can be developed from divisions of the format, whilst the whole remains a pictorial unity.

Drawing and Vitality

William Blake said that an artist charges images with his own energy. We enter into

74 Keith Vaughan (1912–) *Landscape with figures* Pencil (136 × 206 mm) *Victoria and Albert Museum, London*

the image by empathy and infuse it with our own vital motor energy. Drawing is a vigorous activity, where energy is maintained or increased by the mark making process. This can be studied rather well in Stefan Verona's drawing *A seated prophet looking up* (77). The drapery on the prophet's chest is made to fall by a cascade of lines, which ever since I have been aware of the drawing, have given me great delight. These lines are infused with the artist's energy and they also quite remarkably depict the force of gravity acting on the subject. Other marks and lines then create a movement from the prophet's shoulders round to the thighs, further repeated

116

75 Duncan Grant (1885–) *Trojan women*
Oil, body colour and pencil (203 × 286 mm)
Courtauld Institute Galleries, London

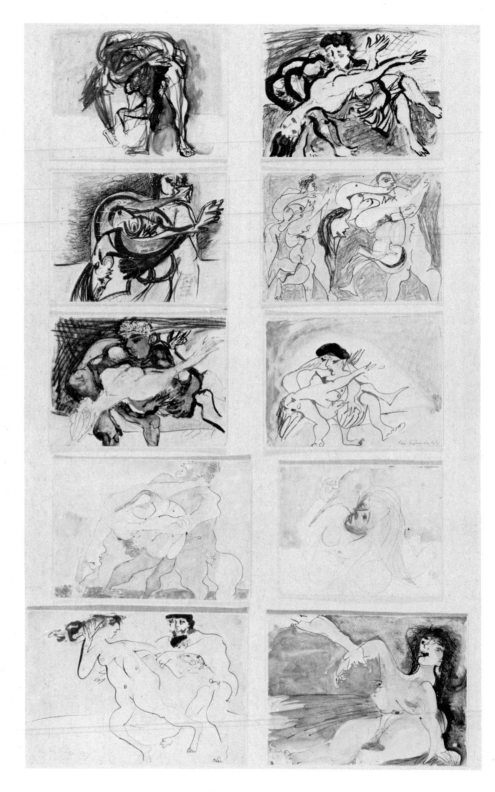

76 Ceri Richards (1903–1971)
Ten studies for the 'Rape of the Sabines'
1 (178 × 252 mm)
Pen, ink and watercolour with
wax crayon
2 (179 × 254 mm)
Pen, ink and watercolour with
wax crayon
3 (179 × 254 mm)
Pencil, pen and ink watercolour
and wax crayon
4 (178 × 252 mm)
Pen and ink with watercolour
and wax crayon
5 (178 × 252 mm)
Pen and ink with watercolour
and wax crayon
6 (178 × 251 mm)
Pen and ink with watercolour
and wax crayon
7 (190 × 280 mm)
Pen and ink with watercolour
8 (177 × 230 mm)
Pencil and watercolour
9 (203 × 314 mm)
Pen and ink with watercolour
10 (204 × 280 mm)
Pen and ink with watercolour
The Tate Gallery, London

77 Stefan da Verona
(1374–1438) *A seated prophet
looking up* Pen and brown ink –
traces of underdrawing in black
chalk (232 × 210 mm)
The British Museum, London

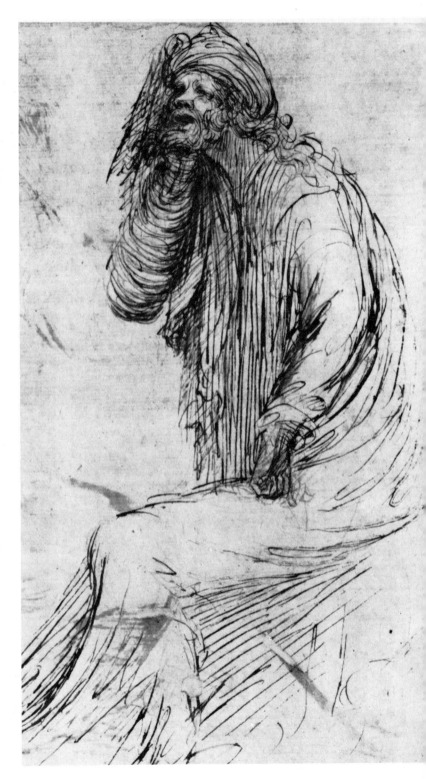

marks make a new movement for the drapery from the knees. A turban and right forearm are depicted by countless bracelet movements which are reminders of Henry Moore's 'London Underground' drawings. There could not be a more vigorous drawing than this and I think one can see how the artist's energy has increased by his mark making process. Vitality and freshness of this kind is quite timeless, in the technique there is nothing to suggest that it is not a recent drawing. In fact it was drawn about 1400. When looking at this drawing I am reminded of the remark by Ossip Zadkine, 'there is no past in art, only an exciting present'.

The drawing of the back view of a sailor was done by a student (78). It was executed in a few minutes. It is a forcible drawing, almost impetuous. He urgently attacked the momentary movement, drawing with a Black Prince pencil. Many marks were laid on to gain the vital shapes, and these of course give the sketch even more movement and suggest the figure is moving to the left. Quite unsophisticated, it is nevertheless an extremely successful drawing. Energy in the attack has infused the image with vitality.

The back view of the seated women by another student is just as remarkable in terms of expended energy (79). The drawing is full of vitality because of the vivacity with which all the contours have been drawn. The position of the woman holding herself up on bent elbows has been seized with relish and a number of sharp forceful lines have been used to convey the power she needs in her arms to hold her body weight. The manner in which the two arms have been seen as enclosing edges of a plane vanishing to the right adds an extra dynamic effect. Elsewhere nuances on head, shoulder points, breasts and hands express an electric discharge effect which adds to the general feeling of visual excitement. Quite a remarkable use of direct energy by a young person, and a very stimulating image.

The drawing by Emilio Greco *Nude study for sculpture* (80) is a good example of deep involvement in the mark making process that leads to textural qualities. This drawing is in pen and ink and shows the vitality of method that can be used with this medium. The paper is plied with fresh and vital pen marks, form modelling arriving by much over lacing of pen strokes. It is perhaps a technique which some illustrators would use; the staccato strokes in the hair, the drawing of the right arm and hand and the trailing hatching on the thigh suggest that the figure is moving. Emilio Greco is an Italian sculptor who has concentrated on portraiture and the female figure. He has made many pen and ink studies of the kind shown.

Walter Sickert's *Old Mr Heffel* (81) is in a much quieter vein than the previous drawings. Although restrained it gives another but equally important view of vitality in drawing. In this drawing movement in the overall image has been played down and the old man sits quite statuesquely on the stool and there are no impetuous markings. Excitement and visual activity is created by many short marks across the forms of the arms and legs. Their abruptness demonstrates the complete confidence the artist has in his drawing technique. This is craftsmanship of a high order and demonstrates how much information on form and space may be packed into a small drawing.

Exceptionally there are drawings which make use of movement but which give very few visual clues about the excitement aroused in the artist in their execution or the energy expended. I have chosen this drawing by Modigliani, one of a number of studies he made called *Caryatid* (82), as an example of this kind.

Modigliani's style is unique. It is difficult to think of any other artist who uses line in quite the same way. Perhaps the Japanese artists Hokusai and Utamaro are nearest to his quality of forcible grace. In this drawing the format is simply divided by the curved shapes of the figure. These lines are however more than edges or contours to forms; they contain the essence of something that is beyond form, they are the subject itself, and of his subject matter the artist said 'it should

78 Raymond Harris 413 × 381 mm

79 Pauline Burbidge
610 × 508 mm

80 Emilio Greco (1913–)
Nude study for
sculpture Pen and ink
(502 × 356 mm)
Victoria and Albert
Museum, London

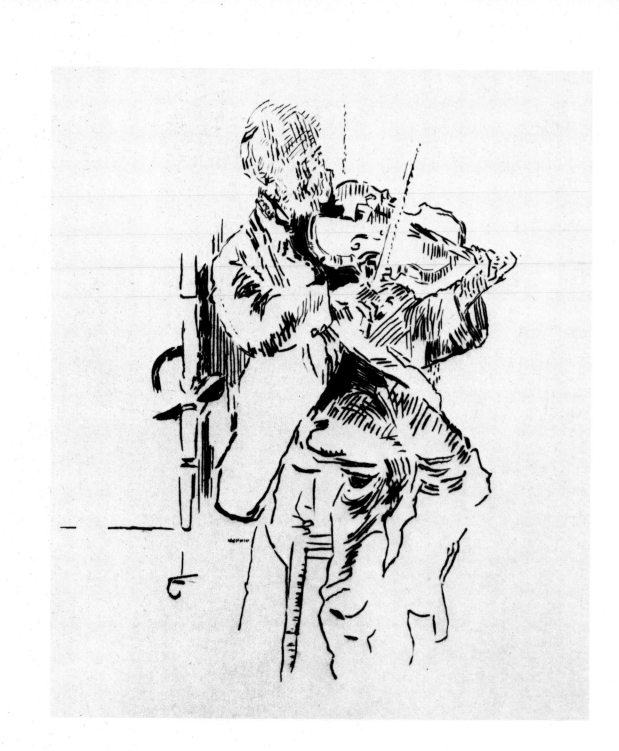

81 **Walter Sickert** (1860–1942) *Old Mr Heffel* Etching (305 × 250 mm) *Courtauld Institute Galleries, London*

82 **Amedeo Modigliani** (1884–1920) *Caryatid* Pencil on paper (549 × 447 mm) *The Tate Gallery, London*

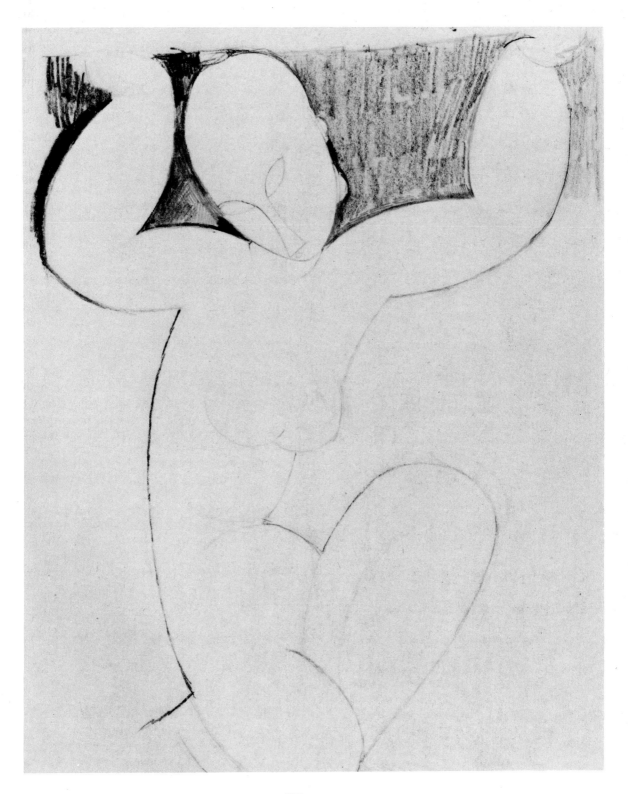

be the receptacle of my Passion'. The medium used in this drawing is pencil, probably a soft lead. It is used with great skill exploiting the full tonal range possible with a pencil. The point has been used to build the heavy black nuances about the right arm and head and the bright black contour on one side of the trunk. Elsewhere the side of the pencil point has been used to obtain an effect of crayon. Other lines are greyer and the pencil being used firmly but with some delicacy. If we look at these lines we can see they have been deliberated over and drawn many times, and it is here that the artist's energy is funnelled in and power exerted. Although graceful they also appear very strong in a physical sense and act like metal springing to hold the top of the format away from the bottom. Each curve has a vibrance endowed during the passion of its construction and each has a significant role to play as a movement in relation to its neighbour. As well there are implied simple architectural movements which serve to unify and strengthen the whole drawing. A flattened S curve comes from the inner thigh up through the body and into the head. Curved movements relate arm to arm, and from each arm to body and legs.

Caricature and vitality

The ludicrous in art really demands a vital approach. To enter the field of caricature drawing one must have a complete mastery over drawing technique to be able to invent a witty and lively style. The best caricaturists never lose the quality of 'livingness' in any exaggeration or distortion of shape. They must have a discerning eye to be able to select the right shapes for exaggeration, but then the distortions must be linked together and made to appear alive in the drawing. Max Beerbohm in his caricature of Beardsley (83) has selected four parts of his subject's head for exaggeration. The nose, the mouth and chin, the ears and the hair, and these features have been linked together to give a burlesque effect of Beardsley's physiognomy. The depiction of the features is very shrewd and we feel that these are the natural shapes

exaggerated. The pointed nose, chin and ears give a waspish look although the pointed ear also adds a puckish note. It is how these shapes are executed that give the cartoon its vitality. In the nose the bridge is noted as if it is broken but it has been kept subservient to the main change of direction at its tip. The drooping chin comes from an ineffectual mouth, and the fusion of the chin with the ear leaves out any angle of the lower jaw. The general direction of the chin's fall is expressed in the line of the cheek from nose to mouth. The ear makes a strong unidirectional movement away from the tip of the nose. The hair, obliterating the eyes, makes sharp opposing directions to the nose ear line and drives down to the chin via the cheekline. The whole head in fact is based on two crossing directions which is its dynamic. The head is barely supported on an exhausted body, but even the exhaustion is treated with wit and vitality. Elbows, shoulder points, fingers and toes are all spiky and alive and all the curves of the contours throughout the body are forcible and not slack. This type of drawing is fun and one which many attempt. I believe it is one way in which we can all try to react to shape and find means of expressing ourselves by drawing.

Vitality and kinetic effects

The most influential form of pictorial art in the twentieth century has undoubtedly been Cubism. Starting with Picasso and Braque, it has been generated on in many styles. Whether one looks at its earliest or latest expression, one of its clearest visual characteristics is the rise of complexities of structured lines or diagonals producing sensations of movement and space. The variation of line structure is part of Cubist technique invented to present separate aspects of a subject on one surface. The visual impression given by such

83 Aubrey Beardsley (1872–98) *Caricature of Max Beerbohm* Pen and ink (295 × 184 mm) *Victoria and Albert Museum, London*

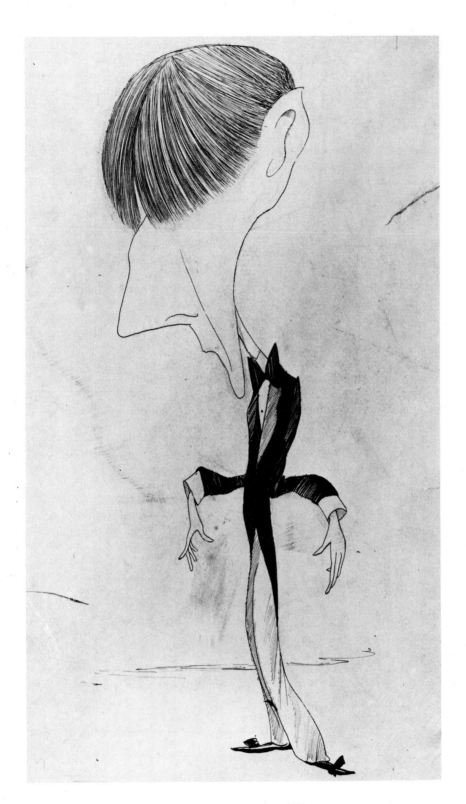

a work is of great activity, the technique giving the artist every chance to express his vitality and energy. The exciting outlook of new improvised techniques has prompted many artists to extend Cubism and make their own contribution. A number worked with figurative images drawing many body parts in repetition to give separate aspects of one figure.

In the work of Marcel Duchamp this was further developed into figurative images portraying a series of transitory movements of body parts in action. His *Nude descending staircase* is the most famous example of this innovation. There are two versions of this work and in one of them, the No 2 version, we are in essence presented with a series of 'stills' from a kinetographic recording of a nude walking downstairs. Most of the lines employed however are not contours of planes and so the figure parts are not completely silhouetted against the background but merge with it. Richard Hamilton was a student and friend of Duchamp and has felt the influence of his work. He is an English artist playing a major role in a movement concerned with New Realism. In his pencil and water colour *Study for a nude* (84) there appears to be a combination of Pop Art, or a portent of Pop Art, and Cubist ideas. The Pop aspect one reads from the lipsticked mouth, high heeled shoes and rather shiny body, an image that might appear in a coloured magazine page. The drawn repetition of body parts is Hamilton's manipulation of Cubist technique. Hamilton has not broken up the figure forms for his contours are the ends of planes. In the trunk repeated contours about the girl's shoulders, back, breasts, and stomach are near enough together to model the forms in the round. Across the front of the shoulders and the breasts the form of the body has been felt, and a strong stress marking the front of the armpit off from the nearest breast provides a major turning point between the direction of the plane of the upper chest and the direction of the plane of the depth of the body from the armpit and through to the girl's back. The stress mark

shows how the dramatic inside change of direction has been felt. Elsewhere in the drawing however the repetition of body parts moves further apart and the effect is more kinetic. The shift from form modelling and feeling out to the suggestion of movement in the arms and legs is a very interesting innovation. This drawing should provide many ideas for those intent on exploring the use of repetition, alternatively it also makes a clear visual statement in support of leaving any previous stages of pentimenti in a drawing to preserve its vitality.

Vitality and improvisation

Another exceptional influence on contemporary visual art and drawing came from the Bauhaus. This is the name of a school of design founded by Walter Gropius of Weimar, Germany in 1919. He gathered round him many artists who were able to energise new teaching methods in design. They looked for fresh visual symbols in pictorial design but gradually came to embrace a Constructivist outlook which led to social uses of form and colour in the field of industrial design. One of Walter Gropius's main advisers was Johannes Itten who provided many of the ideas for Bauhaus theoretical studies, of which the most well recognised part now is his Art of Colour. However Itten was a strongly committed draughtsman. Itten considered the development of drawing skills a vital part of the first course for new students, and in figurative work he considered the essential element was movement. He gave many demonstrations on what he called 'main lines' and movement which aroused great enthusiasm in his students, although they were sometimes dismayed by his emotive and mystical outbursts, for he would sometimes ask them to pray rather than to draw. Certainly there is a religious or

84 Richard Hamilton (1922–) *Study for a nude* Pencil and watercolour (369 × 288 mm) *The British Museum, London*

128

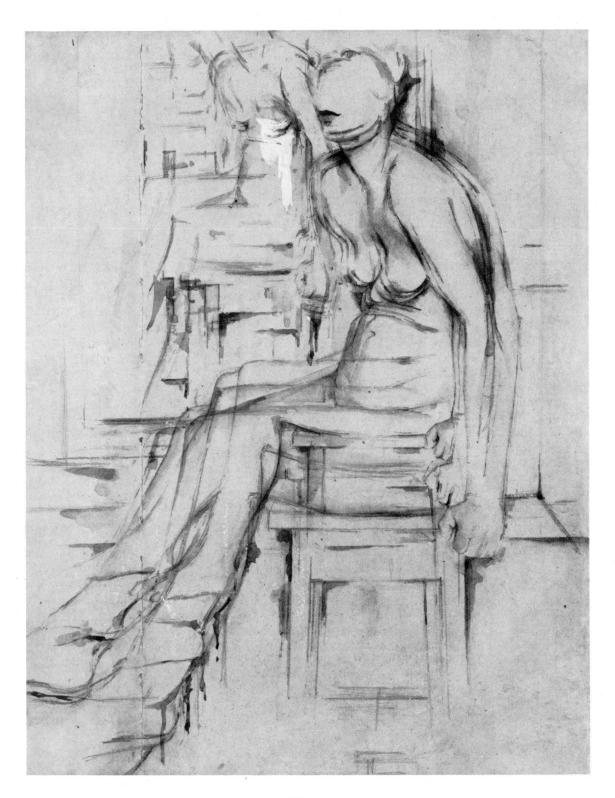

mystical quality in the *Standing female nude* (85), the charcoal and indian ink have been used to make heavy blocks and give a stark Passiontide quality. Vitality here is not in a light vein, the character of the curves and main lines is vehement and harsh; shown by contrast, rather than by any quality in the line itself. This is nevertheless a drawing to be reckoned with. Uninhibitedly it shows us another side of drawing that we all may wish to try on occasions, and that is to make improvisation based on our emotions. In this very personal assertion, Itten has made a drawing that is independent of any other means of visual expression. In it the movements of the human body are used in inspired analogy to portray the spiritual and mystical life of man.

Movement and drapery

Material draped on a figure may hang in folds, cling to the surface, flow over following the planes of the body, or be bunched to create form movements of its own. There is nothing more refreshing than drawing the draped figure after drawing the nude. Generally the drapery of a dress or costume will invest figure forms in a way that reveals their sectional shapes or direction in space. Drapery may be twisted or folded round forms or follow their surfaces by flowing over them. This revelation of section and form lightens the task of analysis. I have chosen Raphael's *Drapery of Horace* (86) to illustrate this idea. In this drawing Raphael was sketching a mantle or Roman toga. This was a loose outer garment thrown over the figure. It is an ideal type of drapery to both reveal figure forms and action and create sculpture of its own. Raphael imagines Horace declaiming and moving forward on his left leg and raising his right hand, his left hand swinging back. There are two very expressive happenings in the drapery as a result of this action; one round the left leg and the other round the left arm. The left arm moving back bunches the drapery over it at the shoulder and Raphael has really enjoyed drawing the heavy folds the material makes.

They are felt sculpturally, their bulk being suggested by modelling in the shadow planes, and also the bunching is shown flowing over the upper arm and amply suggests the form of the foreshortened arm underneath. A swinging movement in space is suggested by the drapery drawn round the left leg, this drops in long loops from the shoulders and back and is pushed forward by the leg. Here again sculpture is suggested by modelling although in a lighter vein. One important thing to note in this drawing is how Raphael has fully exploited the form of the folds in the drapery. Look particularly round the left hand. Pen strokes have followed the direction of the shadow planes as they turn away from the light. This is good drawing practice in itself and of great value, because such feeling for form in the drapery can be transferred to the figure. I quite often drape a model with either a mantle like this, or a form of sari, for my students to draw from. I find there is an immediate improvement in drawing skills because such a study helps both the development of form feeling and feeling for movement. And as well, the extra markings needed to draw drapery bring animation in themselves.

Very often to prepare students for such studies I direct drawings to be made from figures in form fitting costume (87). Asking that all the marks to indicate the costume should mostly come outside the figure so that it is seen in silhouette, and at the same time suggesting the outer marks should be animated and suggest movement. In this way costume can be associated with figure forms and at the same time the marking repertoire can be usefully increased. This form of study scores effectively because the silhouette provides a simple aim, although it calls for observational skills to determine the main changes of direction in the outside edge.

85 Johannes Itten (1888–1967) *Standing female nude* Charcoal, pen and indian ink (165 × 104 mm)
Victoria and Albert Museum, London

86 Raphael (1483–1520) *Drapery of Horace and other studies* Pen, brown ink and black chalk (343 × 241 mm)
The British Museum, London

87 591 × 419 mm

133

88 Alfred Stevens (1817–1875) *Study of a figure (upper part) of an Angel with left arm upraised and right extended; draped with a girdle* Red chalk (254 × 273 mm) *Victoria and Albert Museum, London*

Additionally, it is a form of drawing which provides scope for medium experiment for it is necessary to apply tone markings rather than line. Gathered material following figure forms will greatly enhance form movement. In the study of an angel (88), Alfred Stevens has felt the forward movement of the chest wall by the numerous small folds of material that cover it which sweep up from the waist to the neck. The rotating and flying movements of the arms have been expressed by a similar device. The drawing displays a simple unity of purpose to express movement in space by drapery lines. In this it is a good example, its unfortunate weakness in anatomical understanding may be realised if it is compared with the Raphael study (86).

Drapery and motion

Drapery streaming from a figure can be captured in a drawing from one moment of its movement, and the drapery will appear suspended in space. The fact that we immediately realise from looking at it that the form of drapery captured is transient ensures that it has a kinetic value and motion and movement is implied. In this demonstration drawing (89) I extended the idea of using silhouette to capturing the shapes of drapery blowing away from a figure. Animation and movement is created by the extended shapes of the material and the model's hair in space. The light playing over the movement of shapes is the particular subject of this drawing.

In the drawing of *Woman holding a wreath* by Giovanni di Petro (90), drapery streaming from a figure again provides the forms for an image. It is not an atmospheric study, but rather gives graphic expression to the linear qualities of the drapery. The drapery also makes clear the sculptural qualities of the posed figure and suggests a timelessness, although we realise the woman could move and hold the wreath in other positions. Of great interest is the style of arrested animation given to some of the drapery. It has definite spatial features, all its parts suggesting that it was felt by an inner axial line

undulating away from the legs. If we look at the two sections of drapery in the bodice we can see that they both conform to general geometric forms of a similar kind. The directions of the folds of the drapery all conspire to render the surface aspect of these forms and it is this conception of geometrical form and simple directions that gives the drawing its beautiful formal quality. The Giovanni di Petro drawing is in brown ink which gives all the marking a quality of softness and grace.

In the girl walking (91), I demonstrated to students how a mixture of mediums could be used texturally to add animation to a moving figure. I used the idea of light drapery swinging from the figure with hair streaming from the head. The drawing mediums were pencil, pen and black and brown ink, some water to provide a wash, and white gouache. I used pencil and pen line first. I intended that the drawing should appear light in weight and atmospheric. I used one medium over another quite spontaneously, wanting their use to aid the animation. For example some of the sequins on the skirt are shown in black ink, others indicated by white points, and all the linear movements are repeated in irregular order in all the mediums. This form of rendering is not entirely accidental although the drawing has many accidental qualities. Repeating the linear movements of the drapery in this way enables the process of identification to take place and the character of the fabric and the movement to be successfully conveyed. The movements in the hair and the skirt were deliberately emphasised to give a kinetic value.

Researching drawings made at about the same time as the Giovanni di Petro, which is about the end of the fifteenth century, we would see that many drawings were made by Italian artists which pursued the theme of drapery streaming or billowing from a moving figure. They realised that the depiction of drapery was highly formative in the suggestion of movement in an image, and as well drapery could be conceived following the planes of the body's surface. This use of drapery was not the complete invention of Tuscan

89 597 × 419 mm

**90 Giovanni di
Petro** (1470–1528)
*Woman holding a
wreath* Pen and
brown ink
(235 × 128 mm)
*The British
Museum, London*

91 559 × 381 mm

and Umbrian artists however, but came with the resurgance of pre-Christian Hellenic ideas about form and movement, rediscovered, treasured and extended by them. The ideas found a prepared home in and around Florence, a region which apparently has an indigenous feeling for movement and the harmony of forms, and Florentine artists energetically felt and expressed movement. Lorenzo di Credi, a pupil in the Florentine workshop of Andrea del Verrocchio at the same time as Leonardo, was no exception. I have chosen this drawing (92) as another variant of the streaming drapery type of image, because I believe that together with the Giovanni di Petro drawing it can be of contemporary use. Stylistically it is different from di Petro's drawing. It is much more realistic for in the drapery there is the suggestion of volume as well as movement. The pose of the angel is momentary and it is only the drawing of her curls and the smaller folds at the ends of the drapes that determines she belongs to a time when artists could conceive the Ideal. The study of drapery in the top right hand corner is a useful one, because it is a straightforward three dimensional rendering of drapery bulk. Shadow is used sparingly, yet positively, to model the folds in the cloth, and it is this attitude that di Credi has used to approach the drawing of the angel's clothing. Unlike the di Petro there is a more mysterious suggestion of space and form, rather more the work of a painter than an illustrator, and there is also a feeling for an enveloping light. The drawing's realism and animation is created from a mixed medium drawing technique. It is on a mauve pink surface, first drawn with metal point, then with a brown ink, line, a brown wash being added after that. The whole drawing being finally heightened with white. Throughout the drawing there are light markings on the crest of forms and dark markings in the depths of folds and it is the textured variety that these markings provide that adds animation to the angel's action.

CONCLUDING THOUGHTS

Comprehensibility or mystery?

As a preface to these thoughts I quote what the artist Giorgio de' Chirico said about artistic creation, and the mystery of it:

A work of art must escape all human limits: logic and common sense will only interfere. But once these barriers are broken, it will enter the regions of childhood vision and dream. Profound statements must be drawn by the artist from the most secret recesses of his being; there no murmuring torrent, no bird song, no rustle of leaves can distract him. What I hear is valueless; only what I see is living, and when I close my eyes my vision is even more powerful.

A good drawing will always seem to have a mystery attached to it and this mystery will reach us intuitively.

To suggest movement in figures our drawing must be comprehensible. Comprehensibility means using some kind of precision in relationships, but this does not mean fussiness, for the breadth and power of a drawing depends on an approach open to free manipulation, improvisation and intuitive expression. What is comprehensible in a drawing we can appreciate by reason, and in the ways I have described when drawing we do attempt to be comprehensible. However when drawing the whole consciousness is involved and our imaginations admit the mysteries with the image. It is possible to share what is comprehensible in a technique, but what we gain imaginatively from the 'suggestibility' of a technique and mediums is individual and personal. This is lucky because it means we can not be bullied by a method, I certainly have no wish for this book to bully. Rather I would hope that what I have said on technique will increase the power and range of personal expression and multiply the mysterious. It is virtually impossible to describe in words what is meant by 'suggestibility'. If I were conveying its meaning in conversation, I would use a motion in my hand and caress my fingers with my thumb as I used the word. Something is capable of being suggested by a

technique which is beyond the rules or habits of it. In a great draughtsman's work that pleases, it is the quality that produces an hypnotic effect, we look and have to look again. I do not mean that we are sent to sleep, but certainly our minds are so fixed that they can respond to the suggestions in the work. When we say that a drawing pleases, we probably mean that it pleased our mind and also that our existence has been enhanced. We may have felt that the drawing has a completeness which is vital and stimulating and has touched sympathetic chords in us. Marina Vaizey writing for the *Sunday Times* on her reaction to Daumiers' drawings said – 'his art has a procession of images which retain a high visual voltage'. A high visual voltage is what we must try and obtain.

Scribbling

It would be unwise to consider drawing ever as scribbling, although partly it may be. If one should start with scribbling, hopefully the desire to create form will take over. Victor Pasmore said of it 'in accordance with the process of scribbling, we find ourselves directing its course towards a particular but unknown end, until finally an image appears which surprises us by familiarity and touches us as if awakening forgotten memories buried long ago'.

Size and scale

Many drawings are quite small in size, somewhere between 20 and 45 cm ($7\frac{7}{8}$ and 15 in.). They are miniaturistic in relation to their subject matter. Nevertheless great breadth can be achieved within this size, and the imagination is always employed to determine a scale for a drawing. One of the pleasures of drawing is in determining the scale of the image, and in this scribbling is no help at all. Did you notice that Itten's drawing (85) is only 16.5 cm ($6\frac{1}{2}$ in.) high? The scale appears to be greater because of the manner in which the image has been expressed. The drawing by Watteau of the *Oriental servant* (12) is only 20 cm ($7\frac{7}{8}$ in.) high, a fact I find constantly surprising. The drawing implies a much greater scale; all the detail in it is depicted with such great breadth of vision.

When we are busy making a drawing we are bound to ask if we are using the right medium, or whether our feelings for the image are right. At the same time we shall be determining the scale and size of the drawing. Only the person involved in the drawing can resolve the answer to these questions. Our imagination will provide us with a shifting scale for the image from small to large and the answers are individual and related to experience and intuition and what we can force a medium to express. Some can work with great delicacy with a coarse medium on a small scale, some with great breadth with a fine medium on a large scale. As long as at all times we can see the image rather than the mediums we are using we are probably on the correct course, and then our image will be seen first, and from what it was created second. All the drawings in this book can be seen firstly as figurative images of a particular kind, awareness of the mediums in which they are created comes later and is of secondary importance. The production of the image is the first and last goal.

92 Lorenzo di Credi (1456–1537) *An angel running towards the left and other sketches* Metal-point and ink with brown wash on mauve-pink prepared surface heightened with white (243 × 175 mm) *The British Museum, London*

index